50 PORTRAITS
You Should Know

Brad Finger

50 PORTRAITS
YOU SHOULD KNOW

Prestel

Munich · London · New York

INTRODUCTION

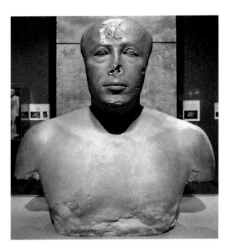

Bust of Prince Ankhhaf, 2520–2494 BC,
painted limestone,
height: 19.9. in. (50.5 cm),
Museum of Fine Arts, Boston

EARLY PORTRAITS: A HISTORICAL JOURNEY
"When Simon first received that high idea
which for my sake he used his drawing pen,
had he then given to his gracious work
a voice and intellect as well as form,
he would have freed my breast of many sighs
that make what others cherish vile to me,
for she appears so humble in her image
and her expression promises me peace.
And then when I begin to speak to her,
Most kindly she appears to hear me speak—
if only she could answer what I say!"
(Petrarch, excerpt from sonnet 78 in his *Canzoniere*)

In his seminal work, *The Canzoniere* (Song Book, ca. 1327–68), Italian poet Petrarch writes eloquently of his love for "Laura." These writings go well beyond the courtly love poetry of Petrarch's day. They also reflect a knowledge of ancient Roman writers, especially Ovid. Petrarch's homage to Laura included two sonnets describing a painted portrait that Simone Martini (ca. 1284–1344), or "Simon," had made of her. For Petrarch, this image seemed to possess the spirit of the real woman. It also brought forth in him the same romantic longings, both rapturous and painful, that Laura had inspired during her lifetime. Petrarch's words offer the first description of how portraiture can affect us. They also represent a key transition period in the history of portraiture—a history that goes back as far as recorded civilization.

THE BEGINNINGS OF PORTRAITURE: MEMORY, REPRESENTATION, AND THE AFTERLIFE

Since ancient times, artists have portrayed the human face with reasonable fidelity. One early example dates from around 2,500 BC, during the Old Kingdom of ancient Egypt. This painted limestone

bust may represent Prince Ankhhaf, half-brother of the pyramid-building pharaoh Khufu. Unusual in Egyptian art, the bust captures individual facial details with remarkable freshness: the bags under the eyes and the full lips, which seem ready to speak. Yet the work's true purpose remains unclear. It was discovered in Ankhhaf's tomb, and it may have been intended to establish his identity in the afterlife.

Two millennia later, ancient Greeks and Romans developed the world's first thoroughly naturalistic art. They also produced writings on how their art should be made. In AD 77, Roman historian Pliny the Elder described how the Greek potter Butades developed a process for making sculpted portraits. Butades first "drew an outline of [the] face on a wall by tracing the shadow thrown by a lamp," and then used his outline as a guide when modeling the final portrait. For Romans like Pliny, portraiture served many purposes. It memorialized people who had died or had left for war. It also served to express commonly held ideals, especially when featuring the emperor. Most surviving imperial portraits are found on coins. These tiny busts capture Nero, Vespasian, and other rulers with highly distinctive features. Yet historians believe they were also idealized in ways that emphasized the general "character traits" of leadership. For example, imperial faces might look unnaturally massive, symbolizing the leaders' power and decision-making abilities, wheras an unusually wrinkled portrait might reflect the "wisdom" that Roman culture associated with age.

Given the delicate nature of paint and wood panels, however, few painted portraits from Roman times exist today. Some of those that did survive were buried under ash in Pompeii. One Pompeian wall fresco likely depicts a local baker and his wife. The wide-eyed couple display symbols of wealth and learning beneath their chins: the stylus and the scroll. Such images were probably meant to exhibit the social status, or at least the pretensions, of Roman households. Yet the work's individualized details—the baker's slightly bulbous nose, the wrinkled forehead, and the scruffy beard—still engage us

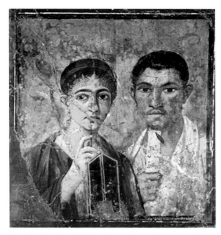

Portrait of the baker Terentius Neo and his wife, 1st century AD,
fresco on plaster,
25.6 x 22.8 in. (65 x 58 cm),
Museo Archeologico Nazionale, Naples

Mummy portrait of a woman, AD 100–120, encaustic on limewood, height: 15 in. (38.2 cm), British Museum, London

today. So, too, do the portrait panels found on Roman-era Egyptian mummies from the Faiyum Basin. These portraits show a diverse array of individualized men and women. The best of them have a vivid, focused intensity that seems designed to recreate the deceased individual's vitality. They also demonstrate Greco-Roman mastery of naturalistic shading and modeling, creating the illusion of a three-dimensional person on a flat surface. This illusion is enhanced by the highly detailed clothing, jewelry, and hairstyles. Mummy portraits generally depicted the local urban elite, and they may have been used to cover up the "unclean" body of the deceased individual.

DONORS AND DEVOTIONAL IMAGES: PORTRAITS DURING THE MIDDLE AGES

When the Roman Empire collapsed in western Europe, the easy naturalism of classical art also disappeared. It was replaced by a more rigid, prescribed Christian imagery. The portrait itself vanished almost completely, barely surviving in the highly stylized depictions of Byzantine rulers. Such works often appeared in mosaic form, such as the sixth-century portrait of Emperor Justinian at San Vitale in Ravenna, Italy. Justinian and his court are given somewhat "personal" features, but their bodies have become flattened and stuck to the wall. The emperor was now more of a symbol than a human being, the lavish purple robes reflecting his secular author-ity, while the halo around his head and the "bread of Christ" in his hands symbolize his role as leader of the Church.

Most medieval portraits would follow Justinian's example. Yet as trade began to increase in Europe, knowledge of the classical past was slowly rediscovered. By the thirteenth century, carvers at Reims and Chartres cathedrals were producing work clearly influenced by Roman sculpture. One of these artists later traveled to German Saxony, where he carved a series of donor portraits (ca. 1250) at Naumburg Cathedral. The men and women he portrayed had died

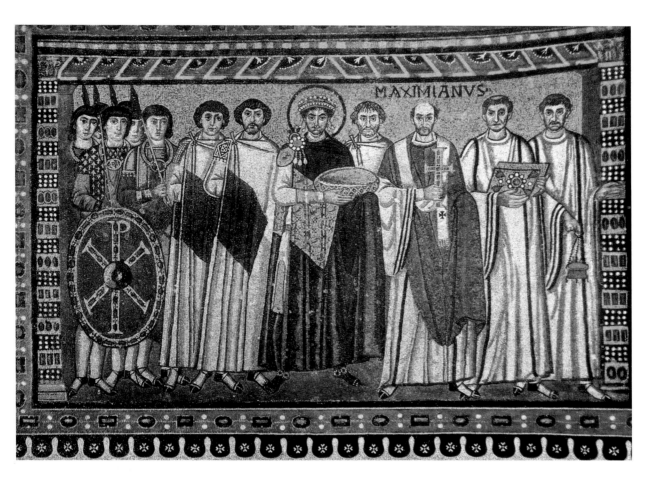

MAXIMIANVS

Mosaic portrait of Justinian and his retinue,
AD 547,
mosaic,
Basilica of San Vitale, Ravenna

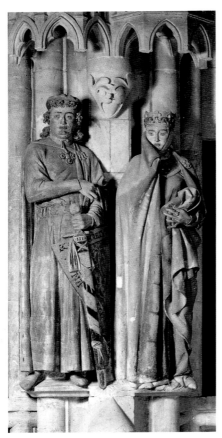

Ekkehard and Uta, ca. 1249–1255,
painted limestone,
height (Ekkehard): 74 in. (188 cm),
Naumburg Cathedral, Naumburg

nearly 200 years earlier, yet the "Naumburg Master" may have used living individuals as his models. His statues honoring Ekkehard and Uta capture fleeting gestures—the adjusting of a sleeve and the covering of a cheek against the cold—that make the couple seem to be in motion on the pedestals. Ekkehard's weathered face, too, is minutely detailed in its depiction of wrinkles and lines.

Advances in medieval portrait sculpture would make their way into painting by around 1300. In the Arena Chapel in Padua, Florentine painter Giotto enlivened his biblical scenes with an array of vivid character types from the urban world of his day—including drunken, potbellied servants, as well as diligent ladies' maids spinning cloth. The chapel also includes a depiction of the donor, Enrico Scrovegni. Though slightly idealized, Scrovegni is vigorously modeled and has a sculptural quality that hearkens back to the ancient frescoes of Pompeii.

The fourteenth century also saw rulers begin to commission truly secular portrait types. In 1317, Robert the Wise, king of Naples, commissioned a devotional painting to celebrate the canonization of his late older brother, Louis, the former bishop of Toulouse. Robert had inherited his position, in part, because Louis renounced his claim to the throne and eventually took vows of poverty with the Franciscan order. The "devotional" altarpiece commissioned by Robert says much about the way family dynasties were using art to promote their own worldly ambitions. Louis is enthroned in a frontal, Christ-like posture, magnificent in his bishop's attire with angels surrounding his head. Below him, Robert the Wise assumes a kneeling position that mimics the donor portraits of his age. Yet Robert's attitude is far from that of a humble servant of the Church. He proudly looks up to his sainted brother as he accepts the crown. His face may even capture certain true-to-life features—especially the beak-like nose and pronounced chin.

Like the altar itself, the artist who created it also represented a new reality in European culture. Simone Martini may have been the

first painter since antiquity to achieve truly international renown. Based in the French city of Avignon—Pope Clement V had recently moved his court there—the Italian-born Martini created an elegant "late Gothic" style that appealed to royal patrons around the Mediterranean. Works such as *St. Louis of Toulouse* helped resurrect secular portraiture as an art form. Martini's influence is evident in his friend Petrarch's *Canzoniere*, which immortalized another of his portraits, and it was around the time of Martini's death that the first "independent" panel portraits begin to appear. The best known of these may depict French King John the Good around 1350 (see pages 22–23). Gone are most of the trappings of sacred art; all that remains is the image of the man, looking very much like Martini's Robert the Wise—half-way between the idealized, devout world of the Middle Ages and the new secular-izing culture of the Renaissance.

Giotto di Bondone, ca. 1266–1337,
Enrico Scrovegni Dedicating his Chapel,
ca. 1305,
fresco,
Capella degli Scrovegni, Padua

MODERN PORTRAITURE: THE RENAISSANCE AND BEYOND
The modern portrait took centuries to develop after Simone Martini's day. Contemporary notions of the "individual" did not take hold until the era of Enlightenment got underway in the eigh-teenth-century. And our understanding of human psychology, with all its internal tensions, was an even later invention. It is therefore difficult to interpret any portrait from before the late nineteenth century—even the most vivid examples by Rembrandt or Thomas Gainsborough—as "exposing" psychological traits. What we can appreciate is how European artists learned to capture the external reality of human faces, and how those portraits depicted human "character" as it was understood by premodern society.

The first radical improvements in portrait painting occurred around 1420 in Bruges, Tournai, and other commercial centers of the Low Counties. Flemish artists like Robert Campin and Jan van Eyck studied the effects of natural light intensively. They also began to explore the artistic possibilities of oil paints. This

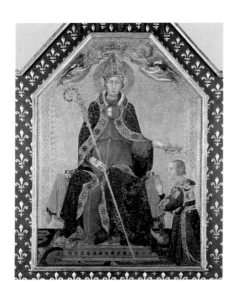

Altar of St. Louis of Toulouse, ca. 1317,
tempera on wood,
100.8 x 54.3 in. (256 x 138 cm),
Museo Nazionale di Capodimonte, Naples

medium was able not only to reproduce the smallest details of a surface—be it skin, fabric, or an inlaid floor—but also to express the subtlest gradations of light and shade. Moreover, the use of glazing and other techniques gave painted surfaces an unprecedented luminosity. All of these qualities transformed Flemish portraits into dazzling optical illusions. For contemporary viewers, paintings such as Campin's *Portrait of a Fat Man* (see pages 24–25) must have looked alive, as though they could step out of their frames and converse with the viewer. This effect was further intensified by the artists' radical new choice of subject matter: the "common" individual. Northern Renaissance art was the first since antiquity to depict nonroyal subjects with regularity. Flemish painters may also have resurrected the self-portrait, as seen in Van Eyck's *Portrait of a Man in a Turban* (see pages 26–27).

By the mid-1400s, the innovations of Van Eyck and Campin had spread to Italy, where they were incorporated into a High Renaissance art in which human skin became softer, postures more relaxed, and symbolism more pronounced. Raphael's *Portrait of Baldassare Castiglione*, from about 1515 (see pages 42–43), portrays the Renaissance author with disarming fidelity, and the figure's composed yet magnetic gaze suggests larger humanist traits of balance, restraint, probity, and inquisitiveness. This work would become a model for countless imperial and aristocratic portraits—of patrons who wanted their image to reflect the best of their culture's values.

Another portrait from this time sought an even deeper engagement between image and viewer. In his self-portrait dated 1500 (see pages 36–37), Albrecht Dürer presents himself in a deliberately provocative, Christ-like manner, staring down the viewer with daring intensity. Modern audiences may regard this work as boldly asserting the power of art over the Church, whereas Dürer's contemporaries in Nuremberg perhaps interpreted it as a statement of faith—the "emulation" of Christ's humility and virtue. In fact, the city of Nuremberg revered Dürer's work for

centuries, displaying it in the *rathaus* (city hall) until 1805. Dürer may have been among the first portraitists who invited viewers to contemplate the value of an individual character. As this publication will make clear, the innovations of Dürer, Van Eyck, and other Renaissance masters helped shape the development of portrait art down to our own century.

50 PORTRAITS

ANONYMOUS
Portrait of Jean le Bon (John the Good)

ca. 1350

Painted portraits go back to ancient times, as can be seen in the funerary portrait panels on Egyptian mummies. Yet the modern portrait developed only as our understanding of human individuality—the "self"—evolved. In the European Middle Ages, people "defined" themselves by the activities they performed or by their station in life, rather than by their individual personalities. Thus the characters in Chaucer's *Canterbury Tales* (late 1300s) are known as "the Knight," "the Miller," or "the Prioress." And though Chaucer does give these characters individual traits, their tales are meant to examine larger principles of Christian society, such as faith, chivalry, and pride.

Medieval art, too, presented human beings according to the services they performed for society and God. Images of the wheelwright or the water carrier appear in thirteenth-century stained-glass windows—people dedicated for their spiritual devotion as window "donors." Kings, too, are shown in medieval art as donors of churches, and they also appear as patrons in illuminated copies of the Bible.

Thus it is unusual to find a fourteenth-century portrait like the one shown here.

The inscription at the top reads "Jehan roy de France," and many scholars believe the man to be French King John II, also known as John the Good. What make the portrait remarkable are its facial features, which are beginning to look individualized: the large nose, heavy chin, and slightly unkempt beard and hair. Most medieval portraits have a far more generalized appearance. The painting also shows the king in simple dress, without crown or other royal insignia to indicate his position. Moreover, the image's profile format—which resembles imperial portraits on Roman coins—suggests an admiration for classical art that would become more pronounced during the Renaissance. Other aspects of the picture, however, link the portrait to medieval tradition. John's face is set against a gold-leafed background, likely emphasizing the role of a medieval king as God's representative on Earth. And most importantly, the talented artist's name is unknown. In a culture where one's labors were usually dedicated to king and church, artists rarely thought of their own work as distinctive or "personal." This attitude would begin to change in the century after John the Good's reign.

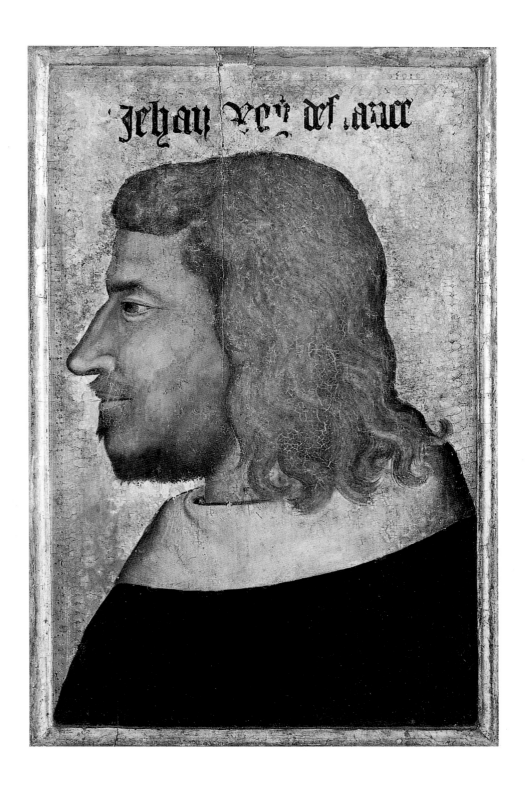

Anonymous, **Portrait of Jean le Bon (John the Good)**, ca. 1350,
tempera and gold on panel, 23.5 x 17.6 in. (59.8 x 44.6 cm), Louvre, Paris

ROBERT CAMPIN
Portrait of a Fat Man

ca. 1425

Historians traditionally divide the Early Renaissance by geography. The Italian version became known for its classical imagery, inspired by newly discovered Roman writings and artifacts. Northern Renaissance artists, based mostly in Flanders, were more interested in the changing urban world around them. Their art, though mostly religious in nature, often captured street life in minute details and in glowing oil paints. Recent scholarship has shown that Robert Campin was a leading innovator of the Flemish Renaissance. Among his achievements, he helped develop an art of portraiture that would influence artists in both the Low Countries and in Italy.

This particular image, commonly known as *Portrait of a Fat Man,* has inspired much scholarly debate. Two versions of the portrait have survived to this day—one at Berlin's Gemaldegalerie and the other one, shown here, at Madrid's Museo Thyssen-Bornemisza. Historians are still uncertain whether either work is by Campin himself or was made, at least in part, by assistants. Even if the latter is true, both versions are of remarkable quality, revealing the craftsmanship that was employed even in making "copies." We see here how closely the artist studied the details and phenomena of nature. Every wrinkle and whisker in the man's skin is elegantly rendered, while every strand of hair on his head and fur collar is delineated. Campin also gives the work a dramatic three-dimensional quality, positioning the head at a slight angle to the viewer and having the subject look away from the light source. This enables the artist to capture all the subtle effects of light and shade, modeling the face to look almost like sculpture. Campin's fleshy visage differs drastically from the stiff profile of John the Good (see pages 22–23), which was made only a few decades earlier.

Fat Man is even more impressive for the way it captures an ordinary individual—possibly a merchant or court official—with great sensitivity. We sympathize deeply with his thoughtful character, despite his rough features. Such art would soon make its way to Italy, inspiring masters like Piero della Francesca to create their own images of unflinching reality (see pages 32–33).

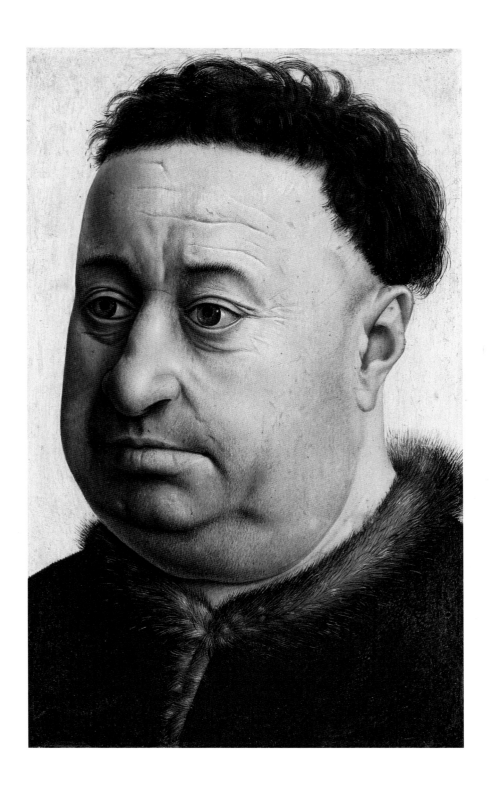

Robert Campin, **Portrait of a Fat Man**, ca. 1425,
oil on panel, 14 x 9.3 in. (35.4 x 23.7 cm), Museo Thyssen-Bornemisza, Madrid

JAN VAN EYCK
Portrait of a Man

"We will never find his equal to our pleasure, who thus excels in his art and science."
(Philip the Good, duke of Burgundy, on his court painter, Jan van Eyck, 1435)

By the early 1400s, Bruges was the key trading link between northern Europe and the Mediterranean. Spices, wool, and silk made their way in and out this Flemish city, and Bruges's merchants merchants developed a stock market and other features of Europe's growing mercantile economy. Moreover, the city's economic ties to Genoa and Venice meant that it shared in Italy's newly flourishing artistic culture—one in which painters and sculptors were achieving new positions of prominence. No longer the anonymous manual laborers of the past, artists were now becoming literate and acquiring prized positions at court. Philip the Good's glowing praise of his court painter, Jan van Eyck, exemplified this dramatic change in cultural attitudes. Indeed, Van Eyck did create art that "excelled" the works of his rivals. The painting shown here may represent an authentic self-portrait. Scholars point to the work's frame, where the inscription has survived in excellent condition.

Van Eyck's writing includes his name and the date—and because no other name is listed, many historians argue that the portrait is of the artist himself. This view is bolstered by the subject's fixed, glossy stare, suggesting the artist may have captured his own weariness after staring into a mirror for hours.

Despite the arguments over his sitter's identity, Van Eyck's work still captivates today. The dark clothes and background focus our attention on the face, which is bathed in natural light. As in Campin's *Portrait of a Fat Man* (see pages 24–25), Van Eyck scrupulously depicts every blemish on the skin, and his mastery of shading gives the face both depth and a natural glow. Also distinctive is the elaborately folded chaperon, a European head garment that was long misidentified as a "turban." All of these details are rendered in luminous oil paints, and they depict a man with a keen intellect and self-awareness, character traits that form part of our modern idea of the artistic temperament.

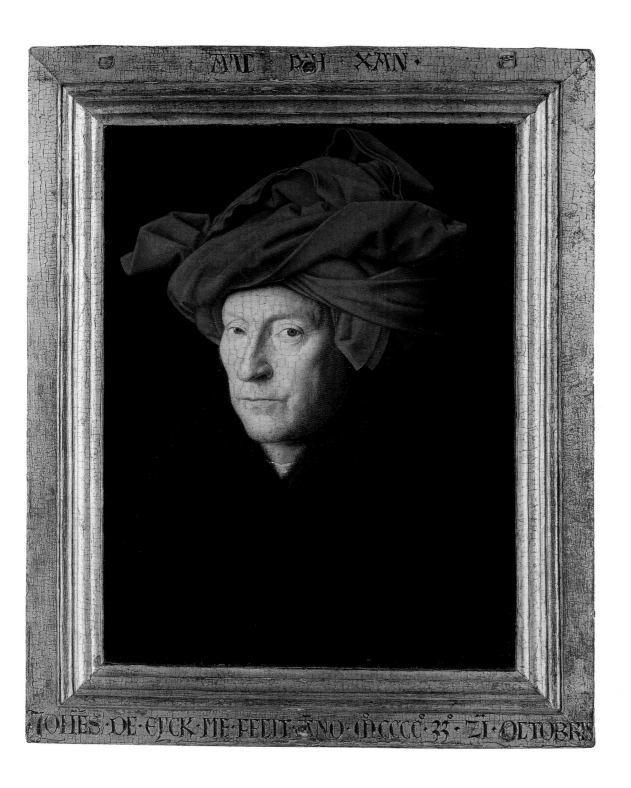

Jan van Eyck, **Portrait of a Man**, 1433,
oil on panel, 10.2 x 7.5 in. (26 x 19 cm), National Gallery, London

PISANELLO
Portrait of Leonello d'Este

"Seeing therefore that we had heard, from the reports of many, of the multitude of outstanding and virtually divine qualities of Pisano's (Pisanello's) matchless art both in painting and in bronze sculpture, we came to admire first and foremost his singular talent and art. But when we had actually seen and recognized these qualities for ourselves we were fired with enthusiasm and affection for him in the belief that this age of ours has been made glorious by one who, as it were, fashions nature herself ..."
(Pisanello's letter of appointment to Alfonso V of Aragon, 1449)

Leonello d'Este was a model Italian Renaissance prince. Though born an illegitimate son, he became the favorite of his father, Niccolò d'Este, and received an outstanding humanist education, learning classical languages, philosophy, and culture. His tutor, Guarino da Verona, was among the first to translate ancient Roman histories into Italian. By the time of his death, Niccolò had arranged for his son to be "legitimized" by Pope Martin V—a process that involved payment of 1,200 ducats—and to succeed him as marquis of Ferrara.

Leonello lived up to his father's expectations. He founded a hospital in Ferrara and became a leading patron of artists and writers. According to tradition, Leonello was one of the first Renaissance patrons to foster competition among artists. For the honor of creating his official portrait, a contest may have arisen between Venetian painter Jacobo Bellini and Veronese artist Pisanello. Local poets recounted how Leonello preferred Bellini's work to that of Pisanello. However, only Pisanello's portrait has survived, and it shows an Italian art in transition. The picture has a two-dimensional appearance typical of Gothic imagery. Yet Leonello's face, though somewhat idealized, captures much of his individual features—his thick lips and sloping forehead. Pisanello also incorporates into the background a small arrangement of roses, depicted with fluid, highly detailed naturalism. Moreover, the image reflects Leonello's admiration for classical history, as it resembles imperial portraits on ancient Roman coins. Pisanello, in fact, helped revitalize the ancient tradition of medallic art, making medals of Leonello, Alfonso V of Aragon, and other Renaissance leaders.

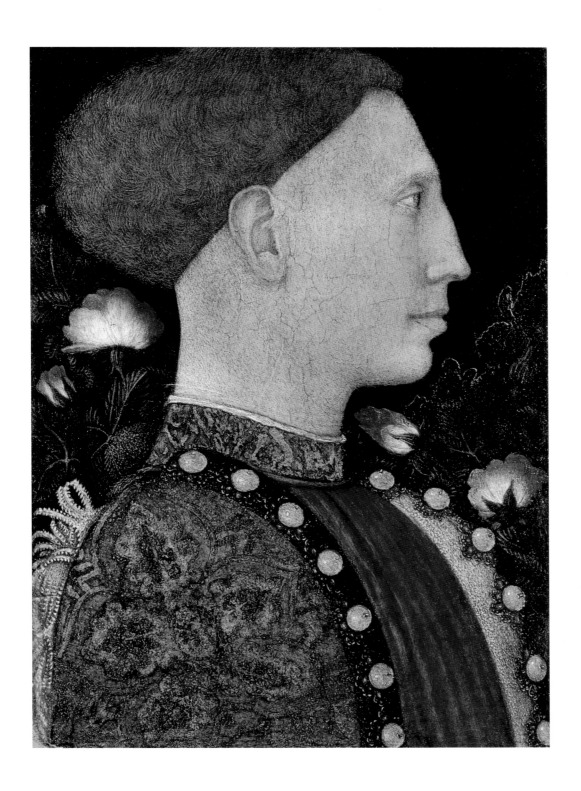

Pisanello, **Portrait of Leonello d'Este**, 1441,
tempera on wood, 11 x 7.5 in. (28 x 19 cm), Accademia Carrara, Bergamo, Italy

ROGIER VAN DER WEYDEN
Portrait of a Lady

ca. 1460

"He has hugely improved our art, for in both invention and execution he achieved a more perfect view of positions and compositions, with the portrayal of man's inner longings and inclinations, whether sorrowful, wrathful or joyful, according to the requirements of the work." (Art theoretician Karel van Mander on Rogier van der Weyden's art, 1604)

As Karel van Mander's assessment indicates, Rogier van der Weyden remained a major influence on Flemish art long after his death in 1464. His ability to depict human emotion in oil paint was revolutionary and long-lasting. Yet because he fell out of favor by the 1700s, art historians have only recently rediscovered many of Van der Weyden's works—works that for years were assigned to other artists.

One portrait, however, has been considered an authentic Van der Weyden for decades. *Portrait of a Lady* now sits in the U.S. National Gallery of Art, and it was likely painted late in his career. The work displays all the qualities of the artist's mature style. The skin is rendered with porcelain-like smoothness, and Van der Weyden uses subtle modeling to give the face the look of

sculpture in low relief. He also displays his mastery of elegant line in the gracefully curved cheek and in the folds of her hairpiece's tissue-thin fabric. Even more remarkable is the woman's expression, whose half-open eyes possess both a restrained modesty and a palpable sensuality. These subtle character traits in the eyes are mirrored in the tightly pulled-back hair and the suggestive full lips and deep red color of the belt.

Some art historians have argued that the painting depicts a noblewoman from the court of Philip the Good or Charles the Bold, both of whom were leading patrons of Renaissance art. Yet such opinions can only be speculation. More likely, the image represents an ideal image of female beauty in the fifteenth century—a beauty both modest and alluring at the same time.

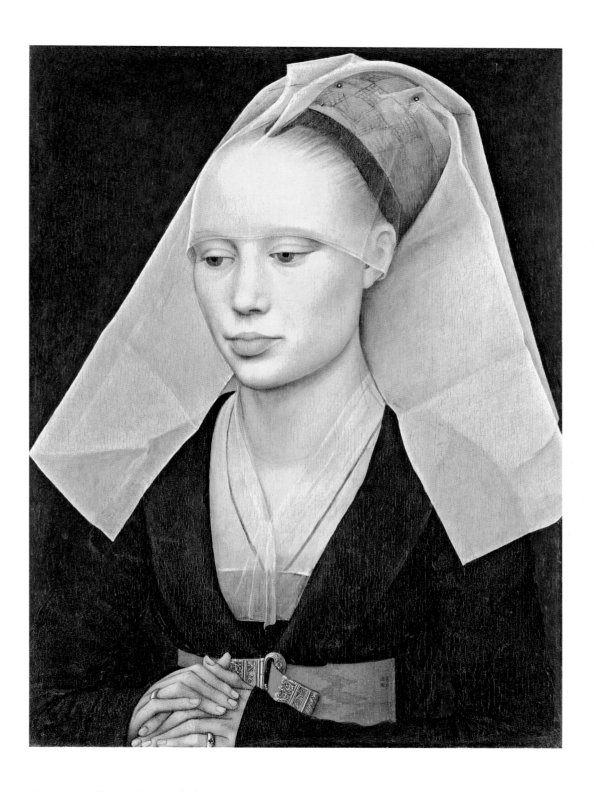

Rogier van der Weyden, **Portrait of a Lady**, ca. 1460,
oil on panel, 13.4 x 10.1 in. (34 x 25.5 cm), National Gallery, Washington, DC

PIERO DELLA FRANCESCA
Portrait of Federico da Montefeltro

"The celebrated [Federico] is borne in great triumph, the fame of his everlasting virtues have proclaimed him a worthy holder of his scepter and the equal of the greatest leaders." (Inscription from the back of Piero della Francesca's *Portrait of Federico da Montefeltro*)

Federico da Montefeltro, duke of Urbino, did much to foster the Italian Renaissance. His vast ducal palace—with its elegant arcaded courtyard—contained one of the largest libraries in Europe at the time. Federico encouraged an artistic and intellectual climate that would make Urbino a breeding ground for artists of the High Renaissance, including the architect Donato Bramante and the painter Raphael. But the one painter most closely linked to Federico himself was Piero della Francesca.

More than most other artists in fifteenth-century Italy, Piero was able to synthesize the classical, idealized forms of Italian early Renaissance art—forms inspired by ancient Roman sculpture— and the precisely detailed, naturalistic style of Jan van Eyck and fifteenth-century Flanders. This combination of styles is nowhere better illustrated than in Piero's image of Federico da Montefel-tro, which is shown here, and in the accompanying portrait of Federico's wife, Battista Sforza. Piero shows Federico in profile, a classical pose adopted by Roman emperors on ancient coins and medals. Yet the duke's face is anything but idealized. Piero depicts his hooked nose and blotchy, wrinkled skin with alarming accuracy. Even the eyes have the slightly weary look of a man who has seen warfare and suffering. Yet they also reveal the duke's keen, magnanimous intellect.

In addition, Piero's tiny image shows off his mastery of linear perspective and naturalistic detail. Federico stands in front of a vast, precisely rendered Umbrian landscape. One can see the reflection of the sailboats in the water and the misty haze covering the hills beyond. The background also uses perspective to give an impression of vast, natural space. Thus Piero employs all of his painterly tools to depict Federico as an ideal Renaissance prince—a man who combines earthy human qualities with great intellectual gifts and a respect for classical tradition.

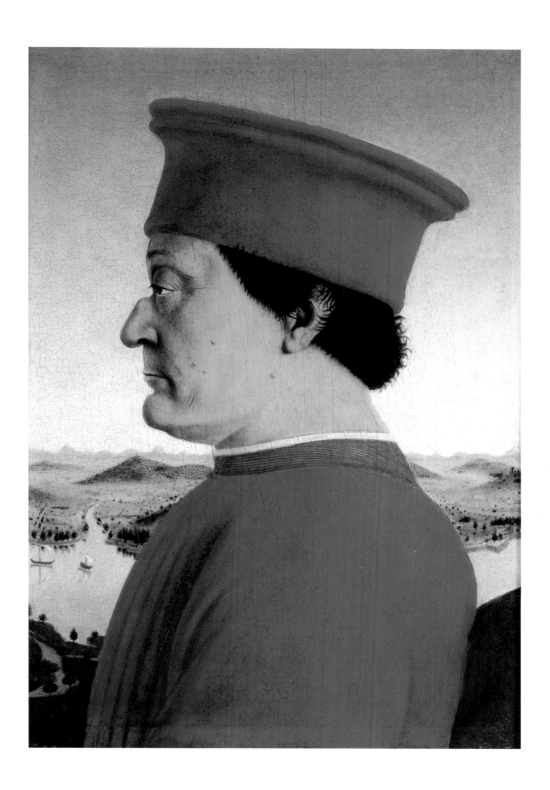

Piero della Francesca, **Portrait of Federico da Montefeltro**, 1465–72,
tempera on panel, 18.5 × 13 in. (47 x 33 cm), Uffizi, Florence

SANDRO BOTTICELLI
Portrait of a Woman (Simonetta Vespucci)

ca. 1480

"In the guardaroba of the Lord Duke Cosimo there are two very beautiful heads of women in profile by his hand, one of which is said to be the mistress of Giuliano de'Medici, brother of Lorenzo ..."
(Giorgio Vasari, from his biography of Sandro Botticelli in *The Lives of the Artists*, 1550)

Simonetta Vespucci was the wife of Marco Vespucci, whose Florentine family had close ties with the Medicis. Yet her beauty captured the imagination of nearly everyone in Florence. In 1475, Giuliano de'Medici entered a famous jousting tournament while bearing a picture of her on his banner. The fact that Giuliano won the tournament, along with Simonetta's untimely death the following year, helped make her famous through-out Italy. And the artist who painted her portrait for Giuliano, Sandro Botticelli, would be inspired to make several more images of "the unparalleled one."

The painting shown here may repre-sent one of those portraits. For decades, scholars had attributed it to Botticelli's workshop, but after the image was extensively cleaned and reexamined in the mid-1990s, many art historians now believe that the master painted it himself—and that the subject of the work is indeed Simonetta. Botticelli was the perfect artist to capture Renaissance female beauty. His gracefully linear style lends a freshness and natural delicacy to her face, even though her features have been idealized. Botticelli also gives the overall image a sensual animation, from the cascading pearls and locks of hair that seem to rustle in the breeze to the swelling folds of her blouse. Yet as critics have argued, these "erotic" qualities are tempered by symbols of purity: her chaste facial expression and the cameo of Apollo and Marsyas around her neck. In the classical story to which this cameo refers, the pride of the lustful nymph Marsyas is punished by Apollo. Such allusions to classical mythology would become a hallmark of much Renaissance art.

When describing Botticelli in his *Lives of the Artists*, Giorgio Vasari may have referred to this particular work. Yet there is no way of proving his story, or of determining whether Simonetta Vespucci was ever the "mistress" of Giuliano de'Medici. Her importance today lies in the artworks her image was able to inspire.

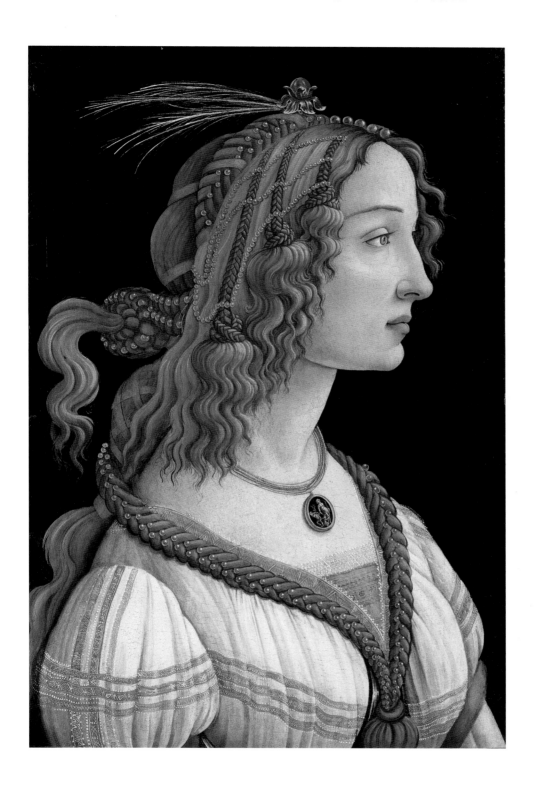

Sandro Botticelli, **Portrait of a Woman (Simonetta Vespucci)**, ca. 1480,
tempera and oil on panel, 32.2 x 21.2 in. (82 x 54 cm), Städel Museum, Frankfurt am Main

ALBRECHT DÜRER
Self-portrait in a Fur Coat

ca. 1500

"Until now many gifted young scholars have turned to the art of painting, but they have not been given proper instruction and have only been taught the technical practice. They have, thus, grown up in ignorance [of painting], like wild trees which have not been pruned. [...] Today, in our [German] land, there are some who revile the art of painting and say that it serves idolatry, that paintings and images lead the Christian to superstitious beliefs, no less [...] but a painting brings more good than harm when it is well made ..."
(Albrecht Dürer, from his treatise *Unterweisung der Messung*, 1525)

Self-portraiture reemerged in Europe during the fifteenth century, but it was Albrecht Dürer who truly established the self-portrait as an artistic genre. In the same way that Rembrandt would do more than a hundred years later, Dürer created images of himself at different stages of his life and career. His earliest self-portrait, made in 1484, shows a wide-eyed, inquisitive teenager in near profile. Over the next sixteen years, Dürer would use his own image to experiment with portrait form and with the depiction of "personal" characteris-

tics. His efforts culminated in the dramatic work shown here.

Even today, Dürer's Christ-like appearance seems daring and provocative. He achieves this effect with his striking, fully frontal position—a position that in 1500 was reserved for images of Jesus. Dürer's long hair, short beard, and raised right hand also allude to devotional paintings, as do the muted brown colors, which symbolize the way Christ was "dirtied" and mistreated. Historians have long argued over the significance of these allusions. Is Dürer's image meant to be virtuous in nature, a man emulating Jesus's humility and spiritual strength? Or is Albrecht brashly claiming God-like inspiration as an artist? Dürer's prominent inscription reads: "I, Albrecht Dürer of Nuremberg, have portrayed myself with appropriate colors at the age of twenty-eight." Thus he may be expressing both the self-confidence and humility that comes with one's transition to adulthood. Whatever the interpretation, this work represents a milestone in the history of art. Dürer's expression engages the viewer with an unprecedented focus and aggressiveness.

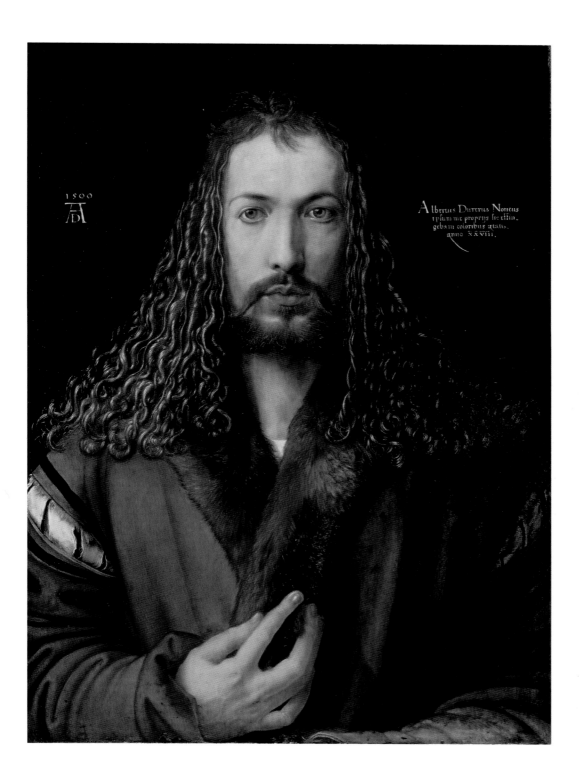

Albrecht Dürer, **Self-portrait in a Fur Coat**, ca. 1500,
oil on panel, 26.4 x 19.2 in. (67.1 x 48.9 cm), Alte Pinakothek, Munich

GIOVANNI BELLINI
Portrait of Doge Leonardo Loredan

Venice was the great metropolis of the Italian Renaissance, one that prized its independent nature and its place at the center of European trade. These characteristics were reflected in the city's head of state. The office of the Doge remained an elected position throughout the Renaissance, and many Venetians felt it symbolized the city's Republican spirit—one that paid homage to the ancient Republic of Rome. Moreover, because the Doge always came from a leading aristocratic family, he also symbolized the city's modern-day wealth and prestige.

Giovanni Bellini's portrait of Doge Leonardo Loredan captured all of these characteristics. Bellini himself grew up in a prosperous household. His father, Jacobo, helped popularize Renaissance art in Venice after he set up the family workshop in 1424. The elder Bellini created the first realistic Venetian cityscapes: drawings famous for their dramatic use of linear perspective. Giovanni would incorporate and build on his father's innovations. By the late 1400s, he had developed a style that mixed the soft, three-dimensional modeling of northern Italian painting, the intricate detail of Jan van Eyck and northern Renaissance art, and a glowing color palette that seemed to reflect Venice itself.

Leonardo Loredan perfectly embodies Bellini's blend of classical idealism and elegant realism. Records indicate that Loredan was a somewhat difficult, prickly individual. The Venetian historian Marino Sanuto the Younger referred to him as "rather choleric." Giovanni's portrait, however, does not attempt to express these real-life character traits. Instead, it symbolizes the power of the Doge as an institution. Bellini presents Loredan with his head facing nearly forward, in contrast to the more typical profile portraits of the age. This composition gives the image a greater sense of depth and realism. Giovanni also reveals his genius for depicting textures and materials. He uses shimmering greens and grays to depict the doge's intricately brocaded silk mantle, and he captures the subtle effects of light and shade on Loredan's slightly weathered skin. All of this naturalism, however, is balanced by the idealized, self-assured expression on the subject's face. The "choleric" doge has been transformed into a symbol of magnanimous, confident leadership.

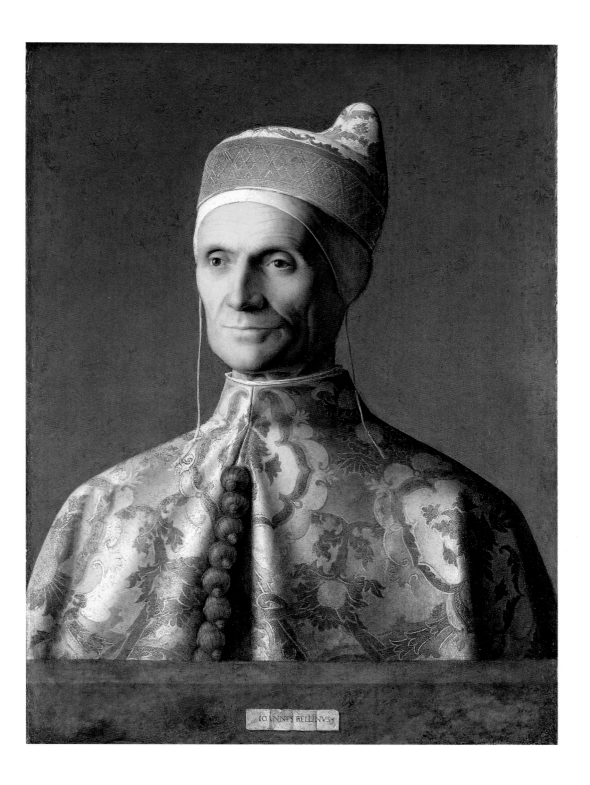

IOANNES BELLINVS

Giovanni Bellini, **Portrait of Doge Leonardo Loredan**, 1501,
oil on panel, 24.3 x 17.8 in. (61.6 x 45.1 cm), National Gallery, London

LEONARDO DA VINCI
Mona Lisa

ca. 1503–06

"Leonardo undertook to execute, for Francesco del Giocondo, the portrait of Monna Lisa his wife; and after toiling over it for four years, he left it unfinished; and the work is now in the collection of King Francis of France, at Fontainbleau. [...] And in this work of Leonardo's there was a smile so pleasing, that it was a thing more divine than human to behold; and it was held to be something marvellous, since the reality was not more alive."
(Giorgio Vasari, from his biography of Leonardo in *The Lives of the Artists*, 1550)

Mona Lisa and her creator have always inspired admiration. As early as 1503, when the work was still unfinished, Florentine clerk Agostino Vespucci cited Leonardo's "head of Lisa del Giocondo" as an example of da Vinci's genius. Later in the sixteenth century, Giorgio Vasari extolled the painting's virtues in detail. Giocondo's "divine" smile would captivate successive generations and eventually make the work a ubiquitous (and often parodied) image in the modern world. It is hard to pinpoint the qualities that give *Mona Lisa* her iconic status. For many tourists who visit the Louvre today, she seems a disappointment, a plain woman without much "personality." In its day, however, Leonardo's image was a strikingly experimental work. Artists prior to 1500 usually portrayed women in a more conservative, stylized manner than the one used to portray men. Women were generally depicted in profile; when they weren't, their gaze was directed demurely away from the viewer (see page 31). Leonardo changed all of that with *Mona Lisa*, who gazes directly at the viewer with an expression both relaxed and suggestive. The naturalism of her posture is enhanced by the soft modeling and play of light on her skin, as well as by the rugged landscape behind her. But Leonardo's work is not all about provocation. He also gives her facial features an idealized coolness; even the shape of her body is a classically refined pyramid. Such characteristics suggest that *Mona Lisa* is more about rethinking the concepts of feminine beauty and modesty than it is about portraying an individual woman. Yet the real meaning of Leonardo's image remains uncertain—inspiring new generations to study and admire the art world's most famous lady.

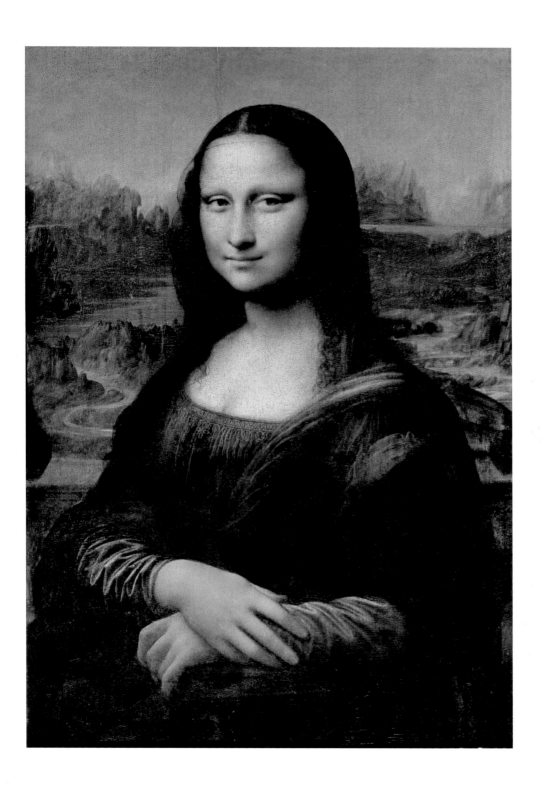

Leonardo da Vinci, **Mona Lisa**, ca. 1503–06,
oil on panel, 30 x 21 in. (77 x 53 cm), Louvre, Paris

RAPHAEL
Portrait of Baldassare Castiglioni

"I say that beauty springs from God, and is like a circle of which goodness is the center. [...] and for that reason outward beauty is a true sign of inward goodness. And this grace is impressed upon bodies, more or less, as an index of the soul, whereby she is known outwardly, as in the case of trees, in which the beauty of the blossom gives token of the excellence of the fruit. The same is true in the case of human bodies ..." (Baldassare Castiglioni, from his *Book of the Courtier*, 1528)

The period of art known as the "High Renaissance" was not defined until the nineteenth century, long after the events of that period had taken place. High Renaissance art was seen to have achieved a complex mix of stylistic elements including naturalistic representation, a convincing sense of three-dimensional space, and a physical beauty that was idealized without looking stiff or rigid. The chief masters of High Renaissance painting were Michelangelo, Leonardo da Vinci, and the artist of the work shown here, Raphael.

The *Portrait of Baldassare Castiglione* displays the remarkable balancing act that Raphael was able to achieve with his art. Castiglione was a famous author and diplomat. His literary masterpiece, *The Book of the Courtier,* examines in dialog form the values of Renaissance humanism; values such as beauty, spiritual harmony, and other features of classical Roman and Greek culture. These concepts, according to the *Courtier*, were embodied in the art of painters like Raphael. In Castiglione's portrait, the bust is rendered in a harmonic, pyramidal shape. And even though Raphael sets the image against an unadorned background, he is still able to capture a sense of depth by the way his sitter is positioned at a slight angle to the viewer. The painter also reveals his mastery of depicting materials. The subject's felt hat, soft beard, and pliant skin are all captured with striking accuracy. Castiglione's expression, too, is somehow both calm and intensely focused, engaging the viewer without being agitated or dramatic. In short, Raphael creates for Castiglione the ideal Renaissance man—and does so in the writer's own image.

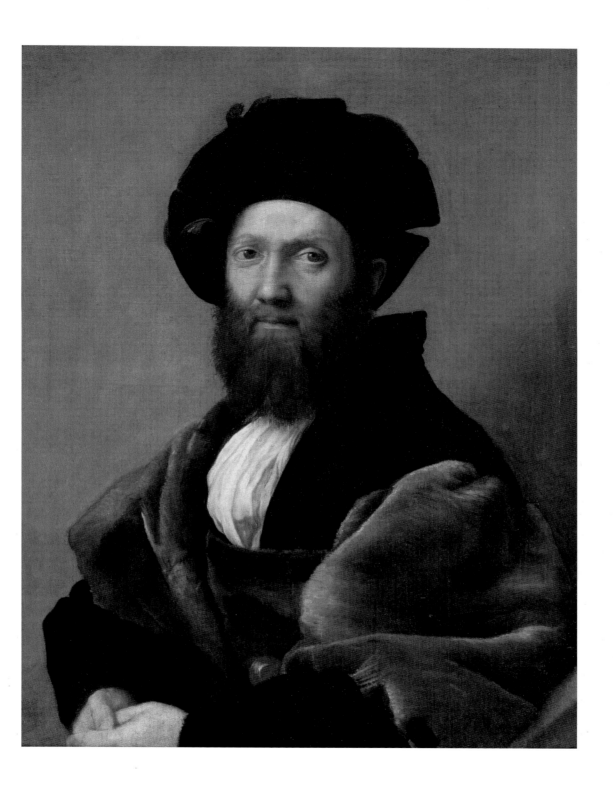

Raphael, **Portrait of Baldassare Castiglioni**, 1514–15,
oil on canvas, 32 × 26 in (82 × 67 cm), Louvre, Paris

PARMIGIANINO
Self-portrait in a Convex Mirror

<div align="right">

ca. 1524

</div>

"In order to investigate the subtleties of art, he set himself one day to make his own portrait, looking at himself in a convex barber's mirror. And in doing this, perceiving the bizarre effects produced by the roundness of the mirror, which twists the beams of a ceiling into strange curves, and makes the doors and other parts of buildings recede in an extraordinary manner, the idea came to him to amuse himself by counterfeiting everything. Thereupon he had a ball of wood made by a turner, and, dividing it in half so as to make it the same in size and shape as the mirror, set to work to counterfeit on it with supreme art all that he saw in the glass, and particularly his own self, which he did with such lifelike reality as could not be imagined or believed. Now everything that is near the mirror is magnified, and all that is at a distance is diminished, and thus he made the hand engaged in drawing somewhat large, as the mirror showed it, and so marvellous that it seemed to be his very own. [...] So happily, indeed, did he succeed in the whole of this work, that the painting was no less real than the reality, and in it were seen the lustre of the glass, the reflection of every detail, and the lights and shadows, all so true and natural, that nothing more could have been looked for from the brain of man."
(Giorgio Vasari, from his biography of Parmigianino in *The Lives of the Artists*, 1568)

Giorgio Vasari's groundbreaking biographical work, *The Lives of the Artists*, was first published in 1550, only ten years after Parmigianino's death. This may explain why the book provides so vivid and detailed an account of the master artist from Parma. Indeed, works like *Self-portrait in a Convex Mirror* greatly appealed to late Renaissance men like Vasari, as they combined "scientific" experimentation with exquisite painterly technique. Other sixteenth-century artists explored their own methods of warping or reconstructing the human face, for example Giuseppe Arcimboldo's "portraits" made of fruits or library books. Such works were among the first to expand the idea of "reality" on canvas.

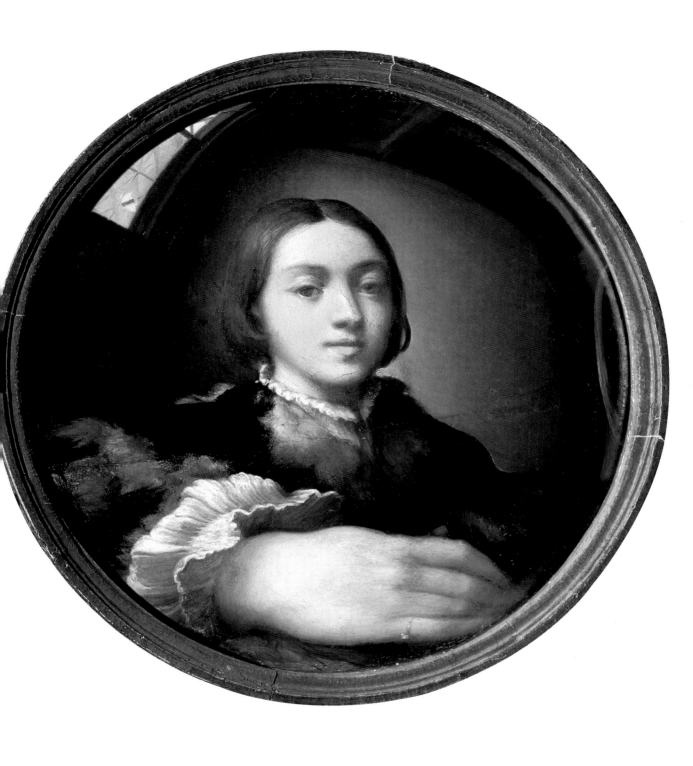

Parmigianino, **Self-portrait in a Convex Mirror**, ca. 1524,
oil on convex panel, 9.6 x 9.6 in. (24.4 x 24.4 cm), Kunsthistorisches Museum, Vienna

LORENZO LOTTO
Andrea Odoni

"Whoever wishes to see how clean and candid his [Andrea Odoni's] spirit is should first look at his face and his house; look at them, I say, and you will see as much serenity and beauty as one can desire in a house and in a face." (Italian author and satirist Pietro Aretino, from a 1538 letter to Andrea Odoni)

The Renaissance saw an unprecedented growth in Europe's merchant middle class. As the wealth of these individuals increased, they began to play an important role in their cities' cultural life. One such man was the Venetian Andrea Odoni, who used his growing fortune to amass a grand collection of art, antiques, and curiosities. His museum-like house became the subject of contemporary authors Pietro Aretino and Giorgio Vasari. Today, Odoni is best remembered for the seminal portrait that Lorenzo Lotto painted of him.

Lotto was also a Venetian, but he spent much of his career on the move— accepting commissions in cities throughout Italy and experimenting with form and technique wherever he went. Though Lotto produced numerous altarpieces and a few larger frescoes, he often seemed most comfortable in the portrait format, where he was able to reveal his natural gifts for expressing individual human character. In his portrait of Odoni, the subject's grand gesture, massive coat, and heavily bearded face lend him an almost regal aura. Yet Lotto also imbues his face with a melancholy, thoughtful countenance, as if Odoni is directly inviting the viewer to gaze at his wondrous objects. And what objects they are! The antique head and torsos seem to possess organic, rippling skin, making them come to life around their proud owner.

Art historians have long argued over the meaning of the work. They note that Odoni holds a pagan statue (possibly of Diana) in his left hand, while his right hand presses a Christian cross close to his breast. This gesture may indicate the primacy of Christian values over worldly riches. However, later generations of viewers would be more influenced by the work's "profane" aspects. During the 1600s, the painting would make its way to Amsterdam, where it would help inspire an even grander age of "middle-class" art, along with images extolling the city's great "art cabinet" collections.

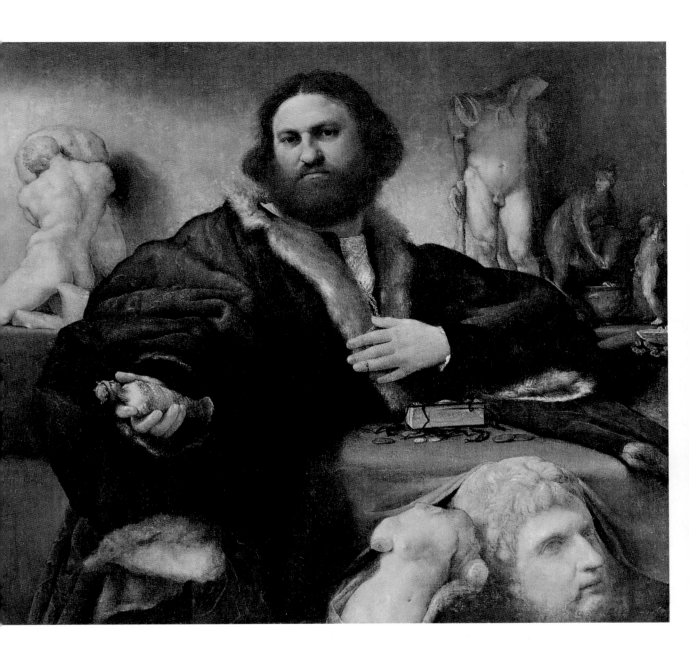

Lorenzo Lotto, **Andrea Odoni**, 1527,
oil on canvas, 41.2 x 45.9 in. (104.6 x 116.6 cm), Royal Collection, London

LUCAS CRANACH THE ELDER

Portrait of Hans Luther (Martin Luther's Father)

1527

Lucas Cranach the Elder was the key portraitist of Germany's Protestant Reformation. He worked for three different Electors of Saxony over the course of fifty years. When he began his career around 1505, Saxony was an underpopulated, remote area of Catholic Europe. Twelve years later, a University of Wittenberg theology professor would forever change the region's fortunes. Martin Luther's Ninety-Five Theses (1517), an intellectual protest against the excesses of the Catholic Church, spearheaded the Protestant Reformation. It also made Saxony an epicenter of that revolution.

Cranach and Luther became friends at this time, and Lucas helped spread the reformer's fame by crafting elegant portraits of him. These images presented Luther as a plainly dressed "man of the people" and as a leader of calm, keen intellect. Cranach's connection with Luther also gave him the opportunity to produce one of his greatest portrait studies. In 1527, Luther's parents visited Wittenberg, probably to attend the christening of Martin's newborn daughter, Elisabeth. Both Hans and Margarethe Luther likely sat for Cranach in his Wittenberg studio.

Cranach's preparatory study of Hans Luther has survived to this day, and it is a remarkably candid image. The artist uses expressive brushwork and boldly detailed modeling to depict the old man's wrinkled skin, rough features, and sharp gaze. Lucas's portrait seems to capture much of his subject's feisty, cantankerous spirit. It also embodies the independent spirit of the Reformation—and the uniquely expressive achievements of German Renaissance art.

Hans Luther also illustrates the vital importance of preparatory studies in Renaissance portraiture. Cranach's studio was a prominent one, and he would receive commissions for multiple portraits of the same subject. Studies such as this one would be used over and over again—by both Cranach himself and his assistants—in order to satisfy their clients' wishes. Yet these "studio" creations were rarely as expressive as the master's original sketches.

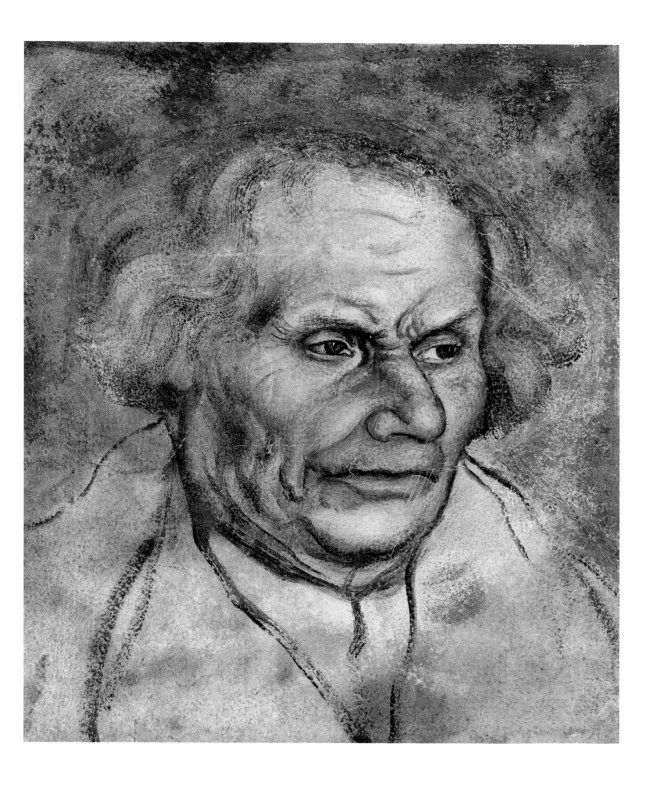

Lucas Cranach the Elder, **Portrait of Hans Luther (Martin Luther's Father)**, 1527, brush and gouache, 8.6 x 7.2 in. (21.8 x 18.2 cm), Albertina, Vienna

HANS HOLBEIN THE YOUNGER
King Henry VIII

"Here must I needs insert a word or two in honor and praise of the renowned and mighty *King Henry the eighth,* a *Prince* of exquisite judgment and royal bounty, so that among cunning strangers even the best resorted unto him, and removed from other courts to his, amongst whom came the most excellent painter and limner [miniaturist] Hans Holbein, the greatest master truly in both those arts after the life that ever was ..." (Miniaturist and painter Nicholas Hilliard on Hans Holbein the Younger, 1598–99)

In about 1536, King Henry VIII requested his official portraitist, Hans Holbein, to create a mural in the Palace of White-hall, then the chief London residence of the English monarch. This Tudor "family portrait" was to include full-length images of Henry and his third wife, Jane Seymour, as well as a posthumous image of his mother, Elizabeth of York. Holbein first prepared elaborate cartoons for the mural's composition. He and his assistants then used these drawings to transfer the outlines of the mural's design onto the palace wall. The image was then filled in with paint. Holbein's mural, which was completed in 1537, suffered an ignominious end—being

destroyed in a fire that burned down Whitehall Palace in 1698.

Yet Holbein's full-length portrait of Henry VIII would become the most widely recognized royal image in English history. Remarkably, the original version of this image—on Holbein's preparatory cartoon—survives to this day. The portrait itself also survives in numerous versions made by Holbein's workshop, including the one shown here.

Holbein was the most successful and technically brilliant German portraitist of the Renaissance. His flair for intricate detail and texture can be seen here in Henry's fleshy face, pursed lips, and chubby hands, as well as the soft fur and gleaming jewels in the royal outfit. Yet it is Henry's piercing stare that directly engages the viewer, providing a window into the real man's often intimidating character. Other features of the work also speak to the notion of regal author-ity, including Henry's massive form and the image's somewhat flattened appear-ance, which hearkens back to portraits of medieval rulers.

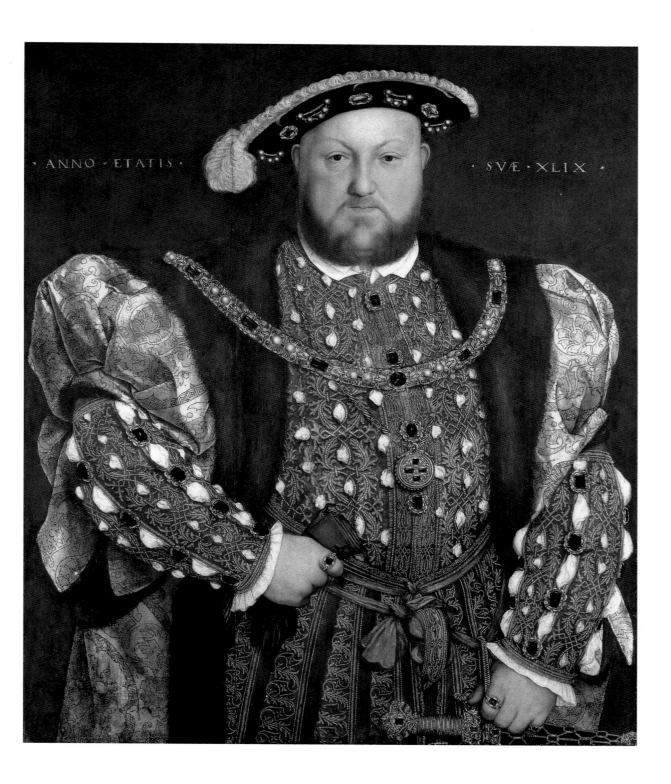

· ANNO · ETATIS · · SVÆ · XLIX ·

Hans Holbein the Younger, **King Henry VIII**, 1540,
oil on panel, 34.8 x 29.3 in. (88.5 x 74.5 cm), Palazzo Barberini, Rome

51

TITIAN
Emperor Charles V on Horseback

"Messer Titian has spent a long time with His Imperial Majesty painting his portrait, and seems to have had plenty of opportunities to talk with him, while he was painting and so on. In short, he reports that His Majesty is in good health, but exceptionally anxious and melancholy ..."
(Poet and diplomat Giovanni della Casa reporting on Titian's 1548 visit with Emperor Charles V, when he painted his equestrian portrait)

Charles V was the most powerful ruler in sixteenth-century Europe. His territories included present-day Germany, Austria, and Spain, along with most of Italy. Charles spent much of his life at war defending his empire, and curtailing the spread of Protestantism in his Catholic lands. Yet he was also a man of taste and learning who fostered the careers of many artists.

In 1547, Charles won a significant victory at the Battle of Mühlberg, in which his largely Spanish army defeated the Lutheran forces of the Schmalkaldic League. To commemorate his victory, he decided to have his portrait taken at the imperial court in Augsburg. But instead of using a local artist, Charles gave the honor to Titian, Venice's most admired painter. The emperor's commission required Titian to travel across the Alps, a rare journey for any artist at the time. Records indicate that Titian established an unusually personal relationship with Charles, and the portrait he produced was unlike any made before.

Equestrian portraits were common during the Roman Empire, but the tradition had been revived only decades before Titian's birth. Here, the Venetian master was able to reinvent the genre for a new age. His depiction of Charles's face achieves a remarkable balance between kingly self-confidence and the "melancholy" of an aging ruler weary of war. Titian's color scheme also gives the work an evocative power—especially in the glowing, restless hues of the sky and in Charles's gleaming metallic armor. The subtle grandeur of Charles V on Horseback would inspire similar masterpieces from court painters who followed him, including Diego Velázquez and Francisco de Goya.

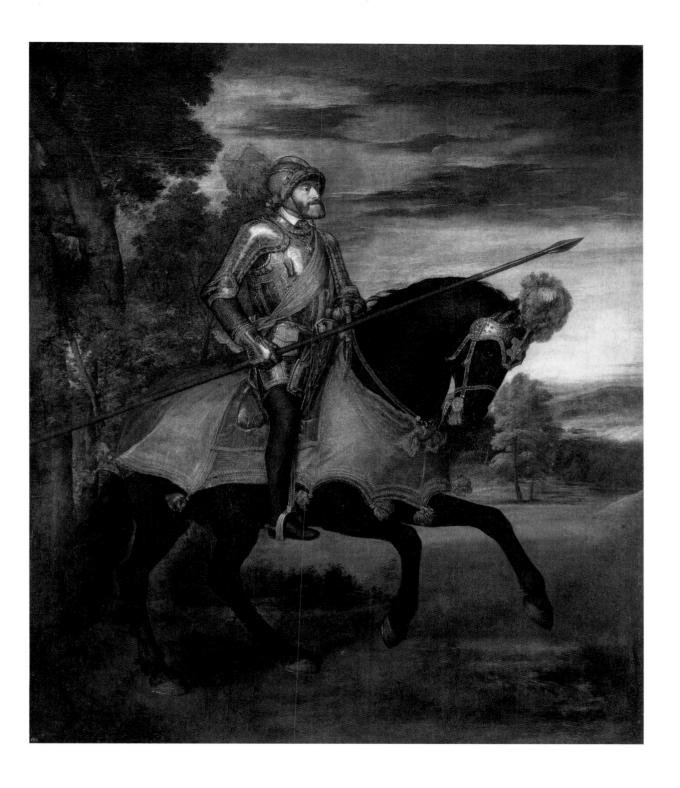

Titian, **Emperor Charles V on Horseback**, 1548,
oil on canvas, 34.8 x 29.3 in. (88.5 x 74.5 cm), Museo del Prado, Madrid

EL GRECO (DOMÉNIKOS THEOTOKÓPOULOS)
Portrait of a Cardinal

ca. 1600

"O Greek divine! We wonder not that in
 thy works
The imagery surpasses actual being,
But rather that, while thou art spared,
 the life that's due
Unto thy brush should ever withdraw into
 Heaven.
[...] Let Nature try:
Behold her vanquished and outdone by
 thee!
Thou rival of Prometheus in thy portrai-
 ture,
Mayst thou escape his pain, yet seize his
 fire: ..."
(From a sonnet on El Greco's art by Fray
Hortensio Félix Paravicino, 1641)

El Greco's "fiery" art was perfectly suited
to his adopted Spanish homeland. Spain
had become a center of the Counter-
Reformation, a cultural and political
movement aimed at curtailing the
influence of Protestant reformers and
reaffirming the primacy of the Catholic
faith. Culturally, the movement often
stressed Catholicism's mystical, spiritual
aspects, as opposed to the more intel-
lectual, literary concerns of Martin
Luther and Protestant bible scholars.
El Greco captured that mysticism in his
biblical images—with their feverish
emotions, swirling forms, and elongated
bodies—as well as in his many portraits.

Because El Greco had settled in the
ecclesiastical center of Toledo, his
portrait commissions often came from
church officials. One of these men was
Hortensio Félix Paravicino, a priest and
poet who praised "the Greek" in his
sonnets. Other commissions were
procured from men higher up in the
church bureaucracy. The subject of the
portrait shown here is not known for
certain, but many historians believe it is
Cardinal Niño de Guevara. Niño was
appointed archbishop of Seville in 1601,
about the time this image was made, and
he is known to have visited Toledo on
several occasions. Despite the sitter's
calm, bespectacled facial expression,
El Greco creates a feeling of drama and
unease in this work. His vibrant brush-
work endows the cardinal's robes and
hands with an electric energy—an energy
enhanced by the slightly warped floor
and skewed depiction of space in the
room. A restless spirit that "surpasses
actual being" seems to inhabit Guevara's
body. Later art historians would note that
Guevara served as head of the Spanish
Inquisition for a time, lending a darker
significance to El Greco's portrait.

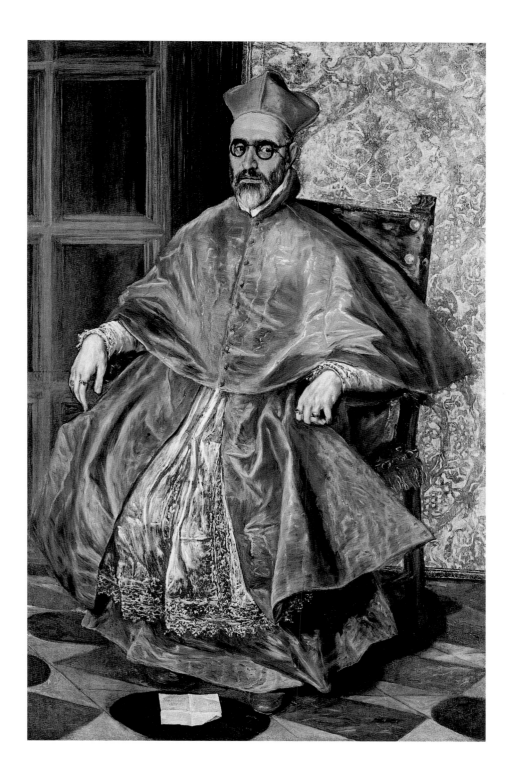

El Greco (Doménikos Theotokópoulos), **Portrait of a Cardinal**, ca. 1600,
oil on canvas, 67.2 x 42.5 in. (170.8 x 108 cm), Metropolitan Museum of Art, New York

PETER PAUL RUBENS
Portrait of Susanna Lunden (Le Chapeau de Paille)

ca. 1622–25

"The productions of Rubens [...] seem to flow with a freedom and prodigality, as if they cost him nothing. [...] The striking brilliancy of his colors and their lively opposition to each other, the flowing liberty and freedom of his outline, the animated pencil, with which every subject is touched, all contribute to awaken and keep alive the attention of the spectator ..."
(Joshua Reynolds on the art of Peter Paul Rubens, 1797)

Baroque master Peter Paul Rubens is best known for his monumental, fleshy, mythological scenes and allegories, images produced for the kings and queens of seventeenth-century Europe. Yet his most personal works were usually done on a much smaller scale. Rubens came from the bourgeoisie of Antwerp, and one of his best clients was Daniel Fourment, a prominent silk merchant in the city. The artist developed an intimate relationship with Fourment's family, eventually marrying his daughter Helena in 1630. Prior to the marriage, Rubens created this engaging portrait of Helena's older sister Susanna. For several centuries, this painting has been known by a misleading title:

Le Chapeau de Paille, or *The Straw Hat*. Yet the sitter's hat is actually made of felt. Art historians point to another portrait of Susanna (in which she does wear a straw hat), suggesting that the two works may have become confused sometime in the 1700s. But despite this inaccuracy, the work clearly represents Rubens at the height of his powers. Fourment's skin is made luminous and plump by Rubens's expert use of line and his gradations of pink and white. These subtle color changes reveal the daytime play of light on her sun-exposed bosom and shaded face. Rubens's painterly trick greatly impressed the eighteenth-century French portraitist Élisabeth Vigée-Le Brun, who devised her own version of Rubens's work (see pages 70–71). Other elements of the *The Straw Hat,* such as the "lively opposition" of blues and grays in the sky and the reddish tones of the dress, also lend vitality to the work—as do the "animated" curves of the feathered hat and the graceful hands. Some critics—pointing to the large ring on her right index finger—believe the portrait was made for Susanna's 1822 wedding to Arnold Lunden.

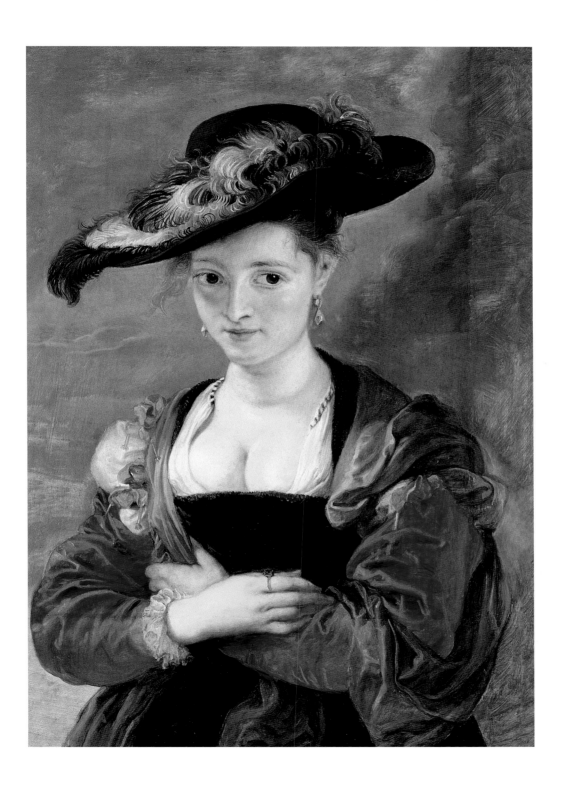

Peter Paul Rubens, **Portrait of Susanna Lunden (Le Chapeau de Paille)**, ca. 1622–25, oil on canvas, 31.1 x 21.5 in. (79 x 54.6 cm), National Gallery, London

ARTEMISIA GENTILESCHI
Self-portrait as an Allegory of Painting

ca. 1638–39

"A beautiful woman, with full black hair, disheveled, and twisted in various ways, with arched eyebrows that show imaginative thought, the mouth covered with a cloth tied behind her ears, with a chain of gold at her throat from which hangs a mask, and has written in front 'imitation.' She holds in her hand a brush, and in the other the palette, with clothes of evanescently colored drapery ..." (Cesare Ripa, an allegory for "Painting" from his 1593 manual *Iconologia* [*Moral Emblems*])

Renaissance and Baroque art relied heavily on symbolic details: objects or figures that could be "interpreted" by a knowledgeable viewer. These images might embody illicit themes, such as cuckoldry or impotence, but they could also suggest grander concepts. Beginning around 1593, an educated Roman servant named Cesare Ripa produced a series of books entitled *Iconologia*, in which he devised precise human allegories for a multitude of professions, ideas, and places. Ripa's works proved influential in the 1600s, affecting the art of Pietro da Cortona and other masters.

Today, the most dramatic example of Ripa's influence can be seen in Artemisia Gentileschi's *Self-portrait as an Allegory of Painting*. Gentileschi was among the first female painters to achieve widespread acclaim in her lifetime. Like many of her male contemporaries, she was inspired by the gritty work of Caravaggio, with its powerful emotional content, aggressive realism, and theatrical use of light and shade. Gentileschi's early works are remarkably frank in the way they capture the violence—both physical and sexual—that can erupt between men and women. This same intensity also comes through in her *Self-portrait*. We can clearly see how she followed Ripa's instructions for an allegory of "Painting": from the dark hair to the twisting body, chain of gold, and "evanescent" drapery. Yet Gentileschi's figure is radically different from the typical images of women in Baroque Europe. Her unidealized face has an almost masculine intensity—as does her powerful exposed arm holding up the paintbrush. All of these elements are achieved with resourceful brushwork.

Remarkably, this provocative image soon entered the collection of English King Charles I, who had commissioned Gentileschi and her artist father to decorate a palace ceiling in Greenwich.

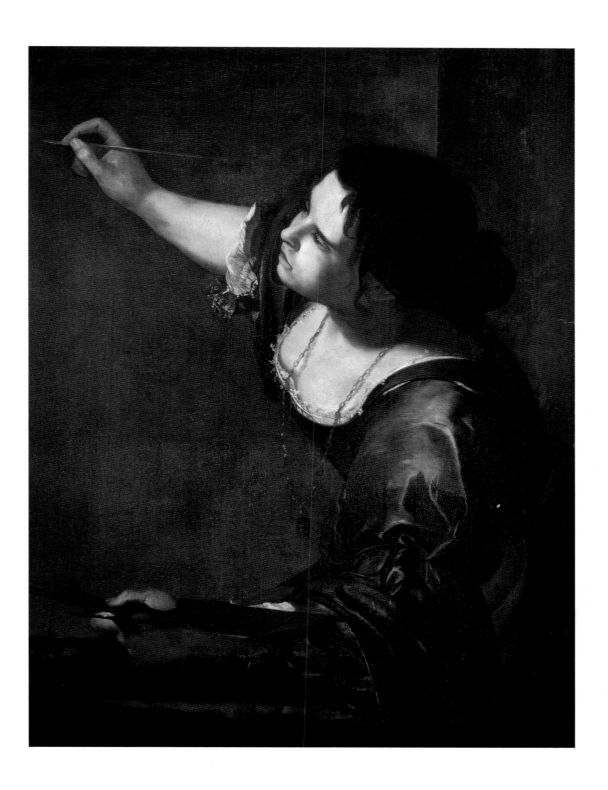

Artemisia Gentileschi, **Self-portrait as an Allegory of Painting**, ca. 1638–39,
oil on canvas, 38 x 29 in. (96.5 x 73.7 cm), Royal Collection, London

DIEGO VELÁZQUEZ
Portrait of Pope Innocent X

"Our Velázquez came to Italy, not however to learn but to teach; for the portrait of Pope Innocent X was the amazement of Rome; all copied it as a study, and looked on it as a marvel." (Palomino de Castro y Velasco, from his 1724 biography of Diego Velázquez)

The papacy helped make Rome a center of European art from the late 1400s through the 1600s. It sponsored the High Renaissance paintings of Michelangelo and Raphael and the curvaceous Baroque sculpture of Gian Lorenzo Bernini. These Italian artists helped transform the art of portraiture—and the image of the Pope himself. But the greatest papal portrait may have been made by an artist from outside Italy. Diego Velázquez was the official court painter to King Philip IV of Spain, which was then the wealthiest nation in Catholic Europe. In 1649, he was sent to Italy to purchase Renaissance art for the Spanish royal collection. He also received an audience with Pope Innocent X, who invited him to paint his portrait. Though Velázquez had lived in Italy for a brief time twenty years earlier, the papal court was relatively unfamiliar with his work. So the portrait he produced in 1650 was a stunning revelation to Innocent and the other artists working in Rome.

By 1650, Velázquez had developed a brilliant technique, employing fluid, impressionistic brushstrokes and a subtle understanding of color. He also had a knack for using posture and facial expression to reveal the knotty and often conflicting aspects of human character. In this work, Innocent's gaze is one of almost brutal severity, his rough facial features—often referred to as "saturnine" and "coarse"—only slightly tempered by Velázquez's elegant modeling of the flesh. Yet the eyes captivate the viewer with a powerful intelligence. Velázquez also draws us in by the way his sketchy brushwork depicts the glittering play of light on the red silk robes and fleshy hands. Even his harmonious color scheme of reds, golds, and whites seems to reflect the intimidating nature of his subject. Velázquez's fearless realism would make *Innocent X* a profoundly influential portrait in centuries to come, inspiring artists from Joshua Reynolds to Francis Bacon.

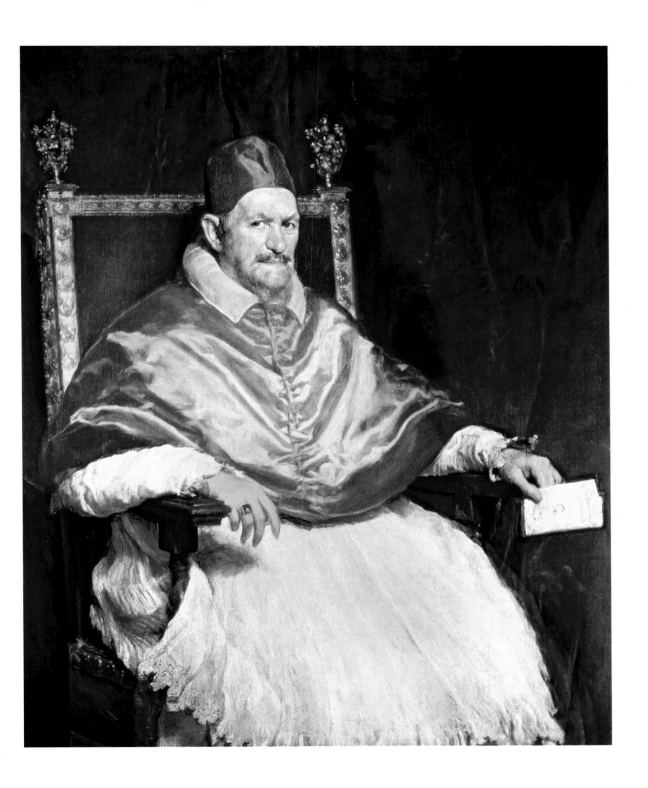

Diego Velázquez, **Portrait of Pope Innocent X**, 1650,
oil on canvas, 45 x 47 in. (114 x 119 cm), Galleria Doria Pamphilj, Rome

JAN VERMEER
Girl with a Pearl Earring

"To see one picture by van der Meer [Vermeer], I travelled hundreds of miles: to obtain a photograph of another van der Meer, I was madly extravagant." (Nineteenth-century art critic Étienne-Joseph-Théophile Thoré)

Great portraits of the past did not always achieve early renown, as the *Mona Lisa* had done. Jan Vermeer was a provincial artist working in the Dutch town of Delft, and he sold few of his works during his lifetime. Only in the nineteenth century did scholars like Théophile Thoré establish Vermeer's modern reputation as a great master. Indeed, his most famous work, *Girl with a Pearl Earring*, has a naturalism and immediacy that seems contemporary to us—and it may not have suited the tastes of seventeenth or eighteenth-century patrons.

Since its "rediscovery," however, Vermeer's masterpiece has been the subject of intense speculation. Historians and writers have offered their own ideas about the girl's identity, some arguing that she was Vermeer's daughter Maria, who would have been about eleven years old when the painting was completed. Others have suggested the girl was Magdalena van Ruijven, daughter of

Pieter van Ruijven—a likely client of Vermeer's. The most plausible analysis, however, is that she was an idealized image meant to represent beauty or purity.

All this speculation speaks to the vividness and emotional directness of Vermeer's art. The girl's frank gaze creates a powerful connection between image and viewer. Vermeer achieves an almost photographic naturalism, in part through his masterful depiction of materials and the play of light. The girl's creamy, smooth skin is produced through highly finished shading and subtle gradations of color—perfectly complementing the satiny texture of her clothing. Tiny daubs of white paint are transformed into pools of light, moistening her lips and adding luster and depth to the magnificent earring. Vermeer shows off this remarkable technique by using a stark, blackened background—a rare instance in which he did not incorporate a domestic interior into his work. For many, *Girl with a Pearl Earring* reflects the tempting, enigmatic nature of the artist himself: the "Sphinx of Delft."

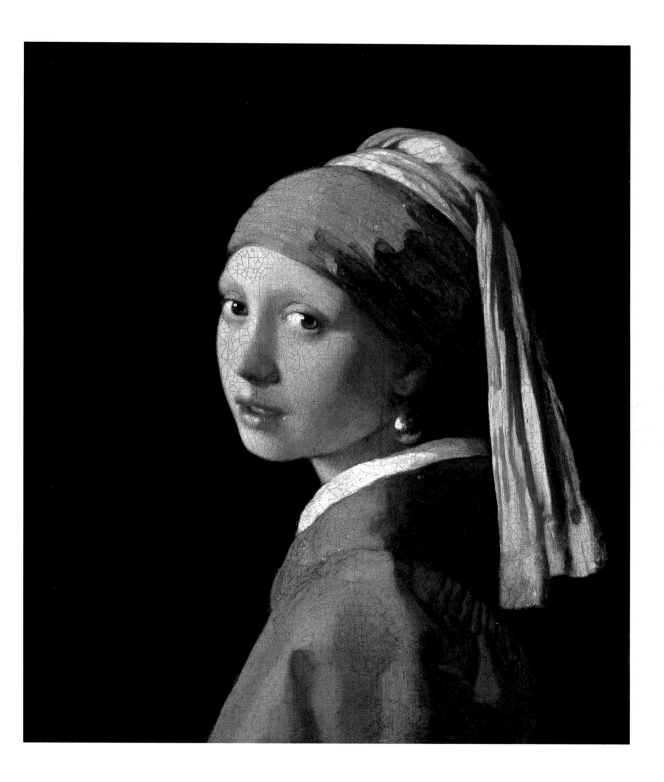

Jan Vermeer, **Girl with a Pearl Earring**, 1665,
oil on canvas, 17.5 x 15 in. (44.5 x 39 cm), Mauritshuis, The Hague

REMBRANDT VAN RIJN
Self-portrait

"Among many portraits deserving of fame that he [Rembrandt] has made, there was one [...] that he had painted of himself, which was so skillfully and artfully worked out that even the best brushwork of Van Dyck and Rubens could not match it; yes, the head seemed to emerge from the painting and speak to the viewers."
(Dutch biographer Arnold Houbraken on Rembrandt's portrait art, 1718)

Rembrandt is widely considered the greatest portraitist in Western art, and much of his reputation lies in his self-portraits. These images document the progress of his life and career. Rembrandt's earliest dated self-portrait captures the young artist as brash and scruffy-haired, a seventeenth-century bohemian. As his career took off in the 1630s, his image became calmer, more self-confident, and even imperious. An image from 1640 shows the artist in lavish, Renaissance-era dress and adopting a pose inspired by Raphael's *Portrait of Baldassare Castiglione* (see pages 42–43). The young man from Leiden has, in his own eyes, become a great master. But with the decline of his business and personal life in the 1650s, the style of Rembrandt's self-portraits would change yet again.

The example shown here perfectly embodies Rembrandt's art at the end of his life. The sixty-three-year-old had recently lost his wife and son, as well as his formerly thriving art career. He was now forced to look inward for sources of artistic inspiration. Rembrandt's late work is remarkable for its technique. The artist uses thick, exposed "brushwork," some of which he applied directly with his fingers, to make his painted materials—skin, felt, and fur—shimmer on the canvas. This quality is also achieved through his expressive use of light, which appears to emanate from within the face. Rembrandt's gaze, too, is remarkable in its subtlety, somehow both calm and painfully introspective. Art historians have recently discovered that Rembrandt altered this work before its completion, changing the position of his hands from active (and possibly holding a paintbrush) to quietly folded. Such changes may have been designed to focus more attention on the face—the face of a man who understands his own mortality.

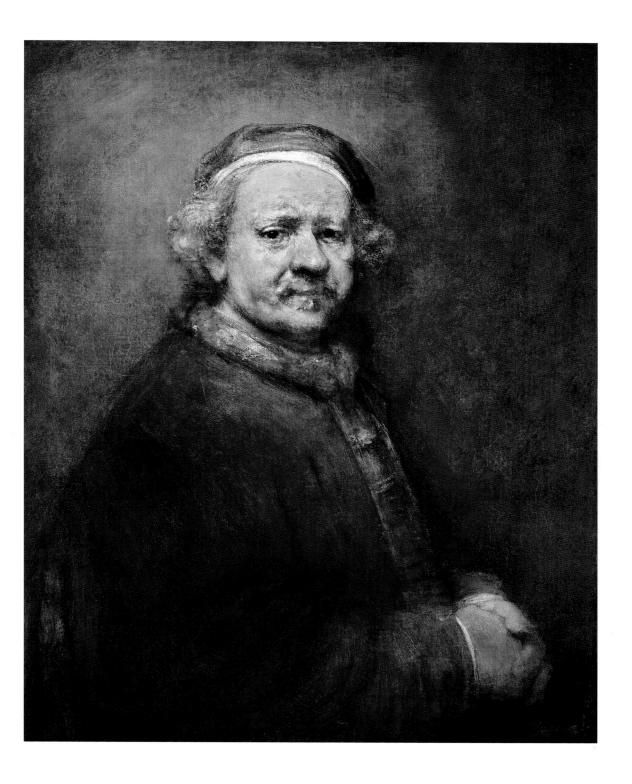

Rembrandt van Rijn, **Self-portrait**, 1669,
oil on canvas, 33.9 x 27.8 in. (86 x 70.5 cm), National Gallery, London

FRANÇOIS BOUCHER
Portrait of the Marquise de Pompadour

1756

"If some of (the artworks) reek of indolence and voluptuousness, and depict people who have become the scandal of their country because of their lives and the happy change wrought by the Revolution in the national spirit, they nonetheless exhibit an excellent taste, a beauty of form, admired by connoisseurs, which can serve as a model for budding artists ..."
(From a 1792 inventory of paintings seized during the French Revolution)

Jeanne Antoinette Poisson took advantage of all the *ancien régime* had to offer: its decadence and its enlightened culture. She received an outstanding education and, upon her marriage, established a prominent Salon that supported the work of writers such as Voltaire. Her estate's proximity to Versailles also gave her access to the royal household and King Louis XV. By 1745, Poisson had separated from her husband and become the latest in a long line of royal mistresses. She also received an official title: the Marquise de Pompadour. Louis XV came to rely on Pompadour's advice on political matters, and she even became lady-in-waiting to the queen in 1756. This event was commemorated by the sumptuous portrait shown here, a masterwork by François Boucher.

Boucher was then the head of France's royal tapestry factory, and his portrait has a brilliant decorative quality typical of the Versailles court. The marquise's body and tiny feet are subsumed in her dramatic, floral-studded dress—its fabric spreading outward like water and merging into the "rippling" curtains. Boucher also highlights the elegant rococo furnishings, using his graceful lines to render such details as the frowning cherub perched atop the bookcase. Pompadour's literary bent is also on display: she is shown with a book in her hand and more "in waiting" on her desk. All of these elements reveal Boucher's mastery of draftsmanship, design, and color.

This particular work would have a curious fate during the French Revolution, when it was seized from the home of Madame de Pompadour's brother. It was placed among a group of works intended for display at a newly proposed public museum in Blois—a museum that was never built. Today, Boucher's portrait is safely housed in Munich, where viewers can still appreciate its "beauty of form."

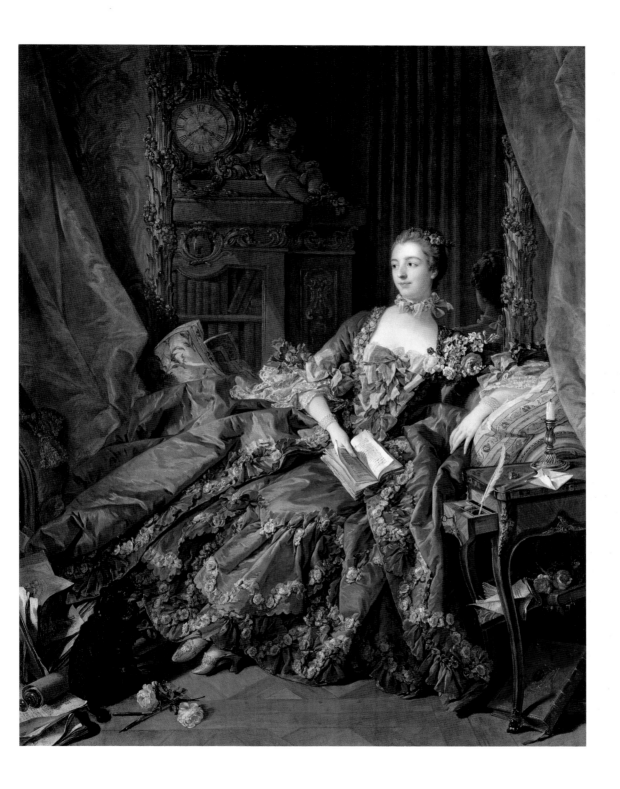

François Boucher, **Portrait of the Marquise de Pompadour**, 1756,
oil on canvas, 79.1 x 61.8 in. (201 x 157 cm), Alte Pinakothek, Munich

THOMAS GAINSBOROUGH
Portrait of the Duchess of Beaufort (Woman in Blue)

ca. 1780

"However, it is certain that all those odd scratches and marks which, on a close examination, are so observable in Gainsborough's pictures, and which even to experienced painters appear rather the effect of accident than design—this chaos, this uncouth and shapeless appearance, by a kind of magic, at a certain distance assumes form ..." (Joshua Reynolds)

The eighteenth century was a golden age of locally born painters in England. These artists set up studios in London and in the fashionable resort town of Bath, where portrait sitting became a favorite pastime of minor nobility, newly enriched merchants, and members of the royal family. Rivalries developed between leading artists, most notably between the country's leading portraitists: Joshua Reynolds and Thomas Gainsborough. Reynolds's style was highly finished and classical, endowing his subjects with a sweet, refined countenance. But it was Gainsborough's work that would prove more influential.

Gainsborough developed a style that could look almost sketch-like in quality. He worked quickly, building up his image with expressive, feather-like brush-strokes and shimmering colors. As Reynolds would describe in a 1788 lecture at London's newly founded Royal Academy, these "odd scratches and marks" seen on close inspection would take shape when the viewer moved away from the painting. A radical technique for the time, it would be adopted in modified form by Claude Monet and other nineteenth-century Impressionists.

But Gainsborough's greatest gift was his ability to flatter the sitters while still revealing their spontaneous individuality. In the painting shown here, Gainsborough seems to capture his aristocratic lady in the midst of movement. Her head turns toward the viewer with a half-open mouth and an alert yet slightly disinterested glance. Her delicate hand adjusts the powder-blue dress, its silken fabric rustling in the breeze. Even her tightly pulled-back hair, with its massive extensions and headdress, seems energized. All of this energy is tempered somewhat by the graceful lines and rounded shapes of her head, neck, and shoulders. Evidence indicates that "Woman in Blue" may be the duchess of Beaufort. Her family included an illegitimate daughter named Margaret Burr—who became Gainsborough's wife.

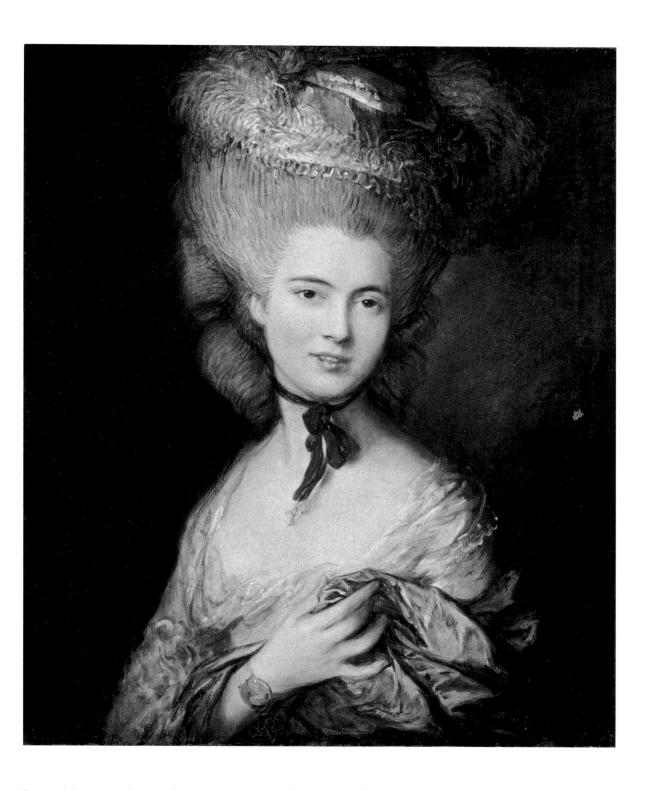

Thomas Gainsborough, **Portrait of the Duchess of Beaufort (Woman in Blue)**, ca. 1780,
oil on canvas, 29.9 x 25.2 in. (76 x 64 cm), Hermitage, St. Petersburg

ÉLISABETH VIGÉE-LE BRUN
Self-portrait in a Straw Hat

After 1782

"Its great power lies in the subtle representation of two different light sources, simple daylight and the bright light of the sun. Thus the highlighted parts are those lit by the sun and what I must refer to as shadow is, in fact, daylight. [...] I was so delighted and inspired by this painting that I completed a self-portrait in Brussels in an effort to achieve the same effect [...] When this picture was exhibited at the Salon, I must say it did much to enhance my reputation."
(Élisabeth Vigée-Le Brun, from her *Memoirs*)

Before the twentieth century, a young painter's education always involved copying the work of earlier masters. Some of these copies stuck close to the original work, such as Peter Paul Rubens's version of *Portrait of Baldassare Castiglione* by Raphael. Other artists were able to incorporate elements of the earlier work—its composition and technique—while still producing an image decidedly their own. Élisabeth Vigée-Le Brun's *Self-portrait in a Straw Hat* is one of these "free imitations."

Élisabeth Vigée-Le Brun was a distinguished society painter in eigh-teenth-century Paris. Like many Rococo artists, she was heavily influenced by the work of Rubens—with its depictions of supple pink skin, sun-dappled land-scapes, and vivid human portraits. Vigée-Le Brun was especially impressed with Rubens's *Portrait of Susanna Lunden* (see pages 56–57), which captured the subtle variations of daytime light on the young woman's face and bust. Vigée-Le Brun effectively mimicked these effects in her own *Straw Hat* self-portrait. Yet her painting's subject is hardly the docile, coquettish figure in Rubens's work. She is erect and self-confident, her probing eyes fixed on the viewer. This type of work did indeed "enhance" the artist's reputation, earning her commissions from Marie Antoinette and other aristocratic female clients in France.

In recent years, a thorough cleaning of this work revealed it to be a copy of Vigée-Le Brun's original *Self-portrait in a Straw Hat*, one that was painted entirely by the artist herself. This discovery testifies to the quality of workmanship that was often employed in "official reproductions" in Vigée-Le Brun's era.

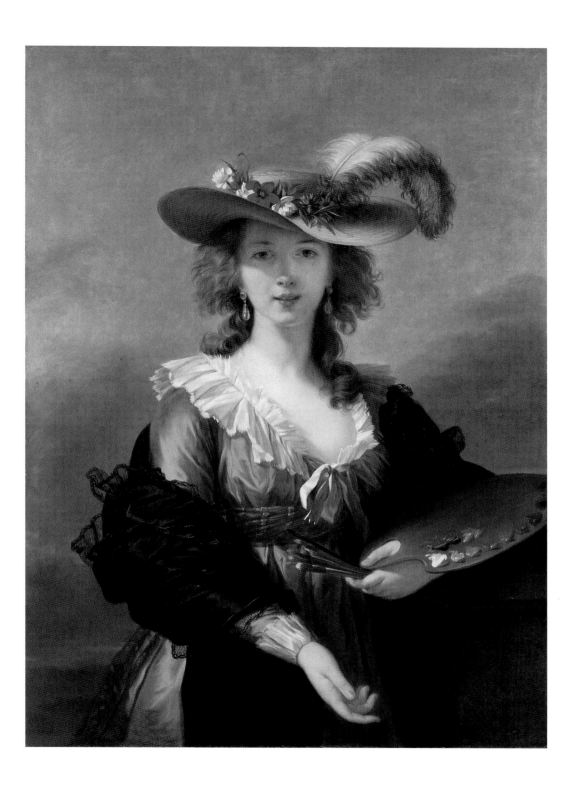

Élisabeth Vigée-Le Brun, **Self-portrait in a Straw Hat**, after 1782, oil on canvas, 38.5 x 27.7 in. (97.8 x 70.5 cm), National Gallery, London

JOHANN HEINRICH WILHELM TISCHBEIN
Goethe in the Roman Campagna

"The large portrait of me, which Tischbein has started on, is already beginning to grow out of the canvas. He has ordered a small clay model from a skillful sculptor and draped it elegantly in a cloak. From this model he is now hard at work painting, for the picture ought, of course, to be brought to a certain stage before we leave for Naples, and merely to cover such a large canvas with paint takes plenty of time."
(Johann Wolfgang von Goethe, from his *Italian Journey*, published in 1816-17)

Portraits of famous individuals sometimes outlive the fame of the artists who made them. Johann Tischbein enjoyed a successful career, serving for twenty years as court painter to the duke of Oldenburg in northern Germany. But today, his career would be little known were it not for a single portrait he produced in 1787. His *Goethe in the Roman Campagna* has become an iconic image in Western art; even Andy Warhol produced his own Pop Art version during the 1980s. Its renown lies mostly in its subject, Goethe, whose poetry and novels represent the pinnacle of German literature during the Enlightenment. Moreover, the image is intricately linked to Goethe's life—being a product of the Italian journey that he and Tischbein took in the 1780s. Both Tischbein and his portrait were featured in Goethe's memoir of the event, *Italian Journey*. But beyond these historical associations, Tischbein's painting remains an outstanding example of neoclassical portraiture. Goethe's reclining position resembles images of Dionysus from ancient Greek sculpture. This posture may have been inspired from a sculptural model that, according to Goethe, Tischbein had procured from a "skillful" Italian craftsman. The artist also includes more overt images of ancient art, including the carved pediment and ionic capital in the foreground and the ruined aqueduct in the distance. During the 1780s, Roman remains were being uncovered at Herculaneum and other ancient sites in the Campagna region, where the painting is set. By incorporating the classical world so thoroughly into his image, Tischbein was presenting his subject—an artist with an inquisitive, balanced temperament—as an inheritor of ancient civilization.

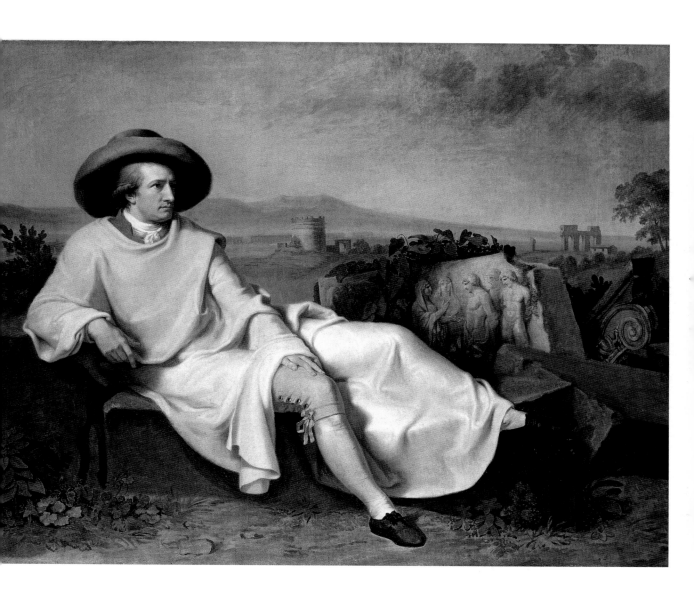

Johann Heinrich Wilhelm Tischbein, **Goethe in the Roman Campagna**, 1787,
oil on canvas, 64.6 × 81.1 in. (164 × 206 cm), Städel Museum, Frankfurt am Main

HENRY RAEBURN
The Reverend Robert Walker (The Skating Minister)

ca. 1795

"In the more trifling circumstances of manner and behaviour, and in the more ordinary occurrences of life [...] the disguise is forgot to be assumed, and we give way to the natural cast of our mind and disposition. It is there we are apt to betray those peculiar features of character, and those often nice shades of distinction, that difference and discriminate us from one another."
(Scottish moralist art critic Robert Cullen on the value of intimate portraiture, 1785)

During the late eighteenth century, the Scottish Enlightenment produced a remarkable array of leading authors, philosophers, scientists, and artists. These men also developed a culture of organized outdoor sport, helping to establish their people's "national character" as rugged and nature-loving.

The major portraitist of this era was Henry Raeburn, who spent nearly his entire career in Edinburgh. His clients included Scottish cultural figures, military leaders, and politicians. Raeburn captured their personalities with great clarity, and his portraits often use local settings as backgrounds. These landscapes reveal Raeburn's talent for depicting the subdued light and atmosphere of his northern land. Yet there is no other painting by Raeburn quite like the image shown here, which shows the Reverend Robert Walker, who was minister at Edinburgh's parish church of the Canongate. Like many men of the cloth, Walker had a wide range of "secular" interests. He authored books on Dutch history, having spent much of his youth in Rotterdam, and was an excellent archer and athlete.

Images of skaters are rare in British art of the period, yet Raeburn captures Walker's posture with great accuracy. He also renders in detail the tightly strapped skates and the curving indentations made in the ice below. But it is Raeburn's use of color and form that is most impressive. The reverend's rich, velvety black attire emphasizes the elegant lines of his back and legs. Raeburn sets this image against an almost abstract landscape of misty hills and a pinkish-gray winter sky. Many scholars feel that the setting is Duddingston Loch, near Edinburgh's Holyrood Palace. But Raeburn's depiction seems generalized, and he may have not had a specific location in mind. For many modern viewers, the image achieves a harmonious synthesis of man and nature.

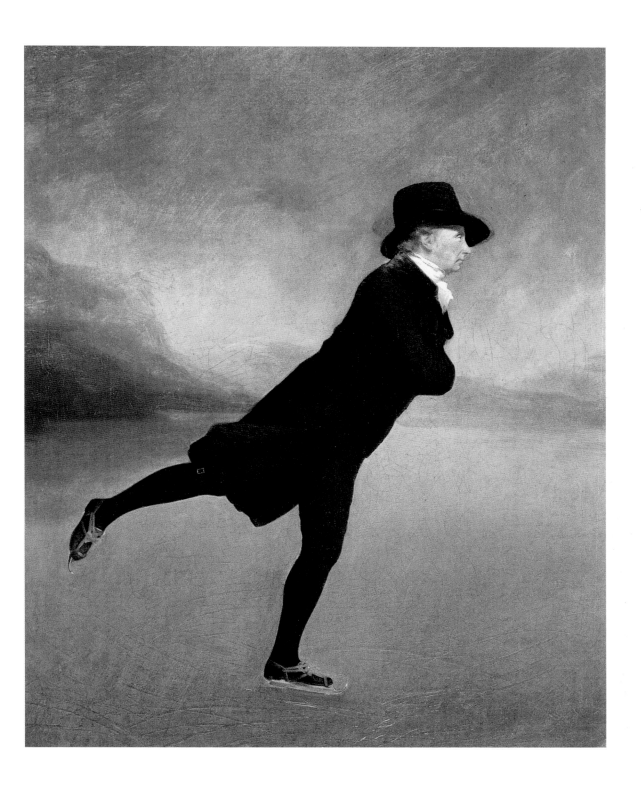

Henry Raeburn, **The Reverend Robert Walker (The Skating Minister)**, ca. 1795,
oil on canvas, 30 x 25 in. (76.2 x 63.5 cm), National Galleries of Scotland, Edinburgh

GILBERT STUART

Portrait of George Washington (Lansdowne Portrait)

"Mr. Stewart, the eminent portrait painter, told me, that there are features in his [Washington's] face totally different from what he ever observed in that of any other human being; the sockets of his eyes, for instance, are larger than what he ever met with before, and the upper part of the nose broader. All his features, he observed, were indicative of the strongest and most ungovernable passions [...] but that, like Socrates, his judgment and great self-command have always made him appear a man of a different cast in the eyes of the world." (Traveler and artist Isaac Weld, Jr. on his conversation with Gilbert Stuart)

Gilbert Stuart was the first great American portrait artist. Yet his art also represents the close cultural ties between America and England in the eighteenth century—ties that were not severed after the Revolutionary War and American independence. Stuart certainly benefited from his British background. He was able to spend the Revolutionary War working in England, where he built up a client base rivaling the top London portraitists. Stuart kept this elite clientele even after moving back to the United States in 1793, and some of his most famous "American" portraits were created for the British aristocracy.

One such work was a full-length image of U.S. President George Washington, now known as the *Lansdowne Portrait*. Widely admired in both Britain and America, he was considered a symbol of the Enlightenment, a man who shunned the title of king and imposed term limitations on his presidency.

Stuart's *Lansdowne Portrait* is similar in style to the royal portraits of eighteenth-century Britain and France. But here, Washington is shown wearing middle-class attire rather than a military outfit or regal robes. And his face, though idealized, retains the look of an elderly gentleman farmer rather than a king. The desk, too, is adorned with "Republican" symbols, including the American eagle and the ancient Roman fasces.

All this "American propaganda" was created for a former British prime minister, William Petty, 1st Marquess of Lansdowne. Petty was a supporter of American independence, and as prime minister he helped secure peace at the end of the Revolutionary War. Thus the *Lansdowne Portrait* shows the power of art to embody and promote momentous political change.

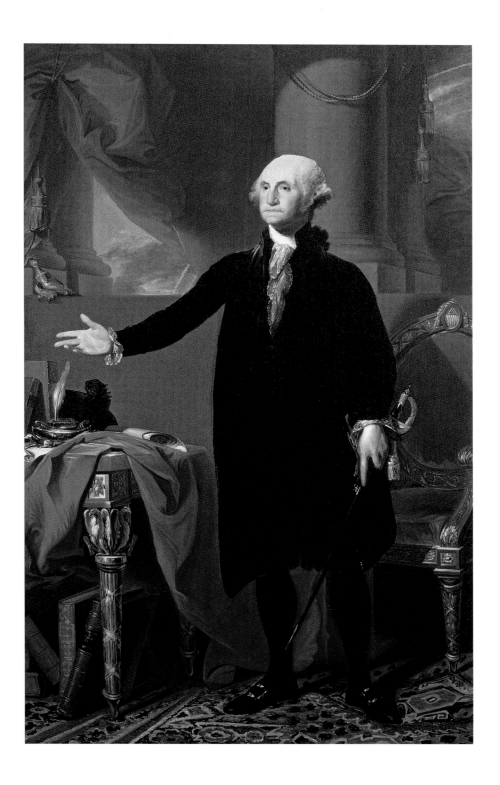

Gilbert Stuart, **Portrait of George Washington (Lansdowne Portrait)**, 1796,
oil on canvas, 96 x 60 in. (243.8 x 152.4 cm), National Portrait Gallery, Washington, DC

FRANCISCO DE GOYA
Mourning Portrait of the Duchess of Alba

"Portrait painting came quite easily to him, and the most felicitous were those of his friends which he finished in a single sitting. He only worked for one session each day, sometimes ten hours at a stretch, but never in the afternoon. The last touches for the better effect of a picture he gave at night, by artificial light. [...] he knew how to create the magic of the atmosphere of a picture, to use an expression which he often employed himself." (Javier Goya on his father, Francisco de Goya, 1831)

Francisco de Goya came from a relatively humble rural background. But his immense artistic talent and gregarious personality helped endear him to the most influential clients in Madrid. Like Thomas Gainsborough, Goya developed a spontaneous style of art that featured rough brushwork and an incisive understanding of character.

Goya sometimes had strong or even ambiguous relationships with his patrons. One such relationship was with a Madrid aristocrat, the duchess of Alba. This strong-willed, impetuous woman had become a widow in 1796, and she was one of Goya's most important portrait clients. The artist once recounted that

Alba "came to the studio to make me paint her face, and she got her way; I certainly enjoy it more than painting on canvas, and I still have to do a full-length portrait of her." Painters were often engaged to make up their subject's faces, but Goya's words suggest that her request may have meant more to him than a professional duty.

This relationship is also suggested in the famous portrait shown here. Alba is wearing the elaborate outfit of a Spanish maja, a class of commoners known for their beauty. This vaguely risqué look is enhanced by her gesture toward the words "Solo Goya" ("Only Goya"), which are written in the earth at her feet. Goya clearly felt a closeness to the duchess, but it is not known whether she reciprocated his feelings. Nevertheless, the portrait is a masterpiece of Goya's art. He uses the simplest, sketchiest of brushstrokes to capture the lace of her outfit and the wooded landscape behind her. Goya also endows her gaze with a belligerence and immediacy that is striking—dramatically at odds with the demure feminine ideal of eighteenth-century Spain.

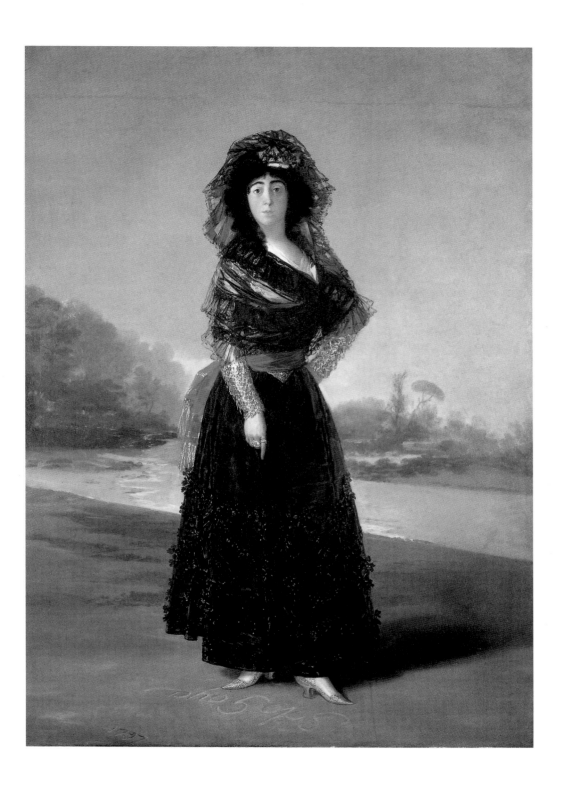

Francisco de Goya, **Mourning Portrait of the Duchess of Alba**, 1797,
oil on canvas, 82.7 x 58.7 in. (210 x 149 cm), Hispanic Society of America, New York

GUSTAVE COURBET
Self-portrait (The Desperate Man)

1843–45

"I have done many portraits of myself in successive states of mind – in a word, I have written the history of my life." (Gustave Courbet)

Throughout the history of art, painters such as Raphael and Rembrandt have used the self-portrait to test newly developed artistic skills—especially at the beginning of their careers. Gustave Courbet painted around a dozen self-portraits during his youth in the 1840s. These works coincided with the height of the Romantic movement, when artists used idealized settings and dramatic attitudes to elicit an emotional response from the viewer. Courbet's early self-portraits depict the artist as a reflective cellist, a wounded soldier, and a haughty young gentleman with pipe and black dog.

But the most overtly dramatic of these works is now known as *The Desperate Man*. Here, the young Courbet appears to be lunging out of the frame, creating an aggressive intimacy between viewer and image that violates traditional rules. Yet one also senses an emotional distance from the painter, whose wild-eyed expression seems to be directed at a mirror—and thus repre-sents self-reflection and an introspective nature. Courbet's image likely reflects his early interest in Old Masters, especially the Baroque artists of Spain and Holland. Art historians have argued that the flowing hair and open mouth, as well as the modeling of the hands and shirt, resemble the fashions and heightened drama of seventeenth-century religious paintings.

By the 1850s, Courbet would move away from the artificiality of Romantic art toward an earthy, non-idealized style that came to be known as Realism. Yet he remained fond of *The Desperate Man* long after his art reached maturity. Courbet kept it as a prized possession in his studio, and he even exhibited the work toward the end of his career in the 1870s. Today, the painting remains one of Courbet's most popular and accessible images.

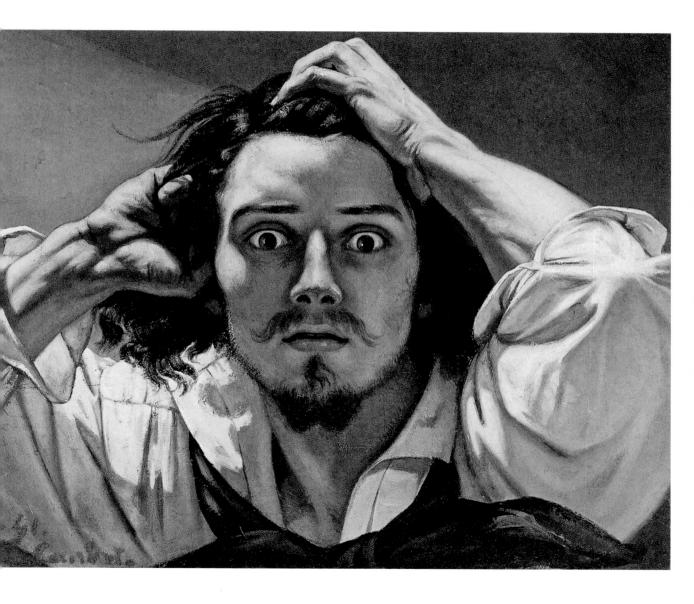

Gustave Courbet, **Self-portrait (The Desperate Man)**, 1843–45,
oil on canvas, 17.7 x 21.3 in. (45 x 54 cm), private collection

ÉDOUARD MANET
Portrait of Émile Zola

1868

"A young painter has obeyed, in a very straightforward manner, his own personal inclinations concerning vision and understanding; he has begun to paint in a way which is contrary to the sacred rules taught in schools." (Émile Zola on Édouard Manet, from his 1867 essay "A New Manner in Painting: Édouard Manet")

Édouard Manet was a true nineteenth-century artist. He collected ideas and influences everywhere he went. On his travels to Holland, Italy, and Spain, he absorbed the vivid Dutch portraiture of Franz Hals, the mythological imagery of Raphael and Titian, and the expressive brushwork of Diego Velázquez's Spanish court scenes. He was also inspired by a newly available art form in Paris, the Japanese print—with its playful use of color and flattened composition. But as much as anything else, Manet absorbed the social life in his city's cafés, gardens, and streets, a social life being transformed by Paris's growing middle class.

All of these influences can be seen, quite literally, in his portrait of the author and critic Émile Zola. Manet and Zola had been close friends since childhood, and in 1867 Zola had published a series of essays in support of his friend's art. Manet had exhibited his work *Olympia* at the 1865 Paris Salon. This provocative reimagining of Titian's *Venus of Urbino* presented the classical nude as a somewhat disinterested, modern-looking Parisian model. The "vulgarity" of Manet's *Olympia* enraged the public and many critics, but Zola praised the work as a daring commentary on modern life. In return for his friend's troubles, Manet painted Zola's portrait in 1868.

The painting presents Zola in the same spontaneous, unheroic manner with which he treated many of his subjects. Surrounding the author is Manet's own "collection" of influences, from the Japanese prints to the Baroque-style upholstery on the chair to the copy of Velázquez's *Bacchus* on the wall. Édouard even includes a reproduction of *Olympia,* a direct reminder of Zola's friendly favor. *Zola* also reveals the "original" qualities of Manet's art, especially in its fluid, daring brushwork and in the way its space is flattened into a collage of interlocking rectangles. For many nineteenth-century viewers, Zola and his surroundings represented the complex patchwork of the "modern" mind.

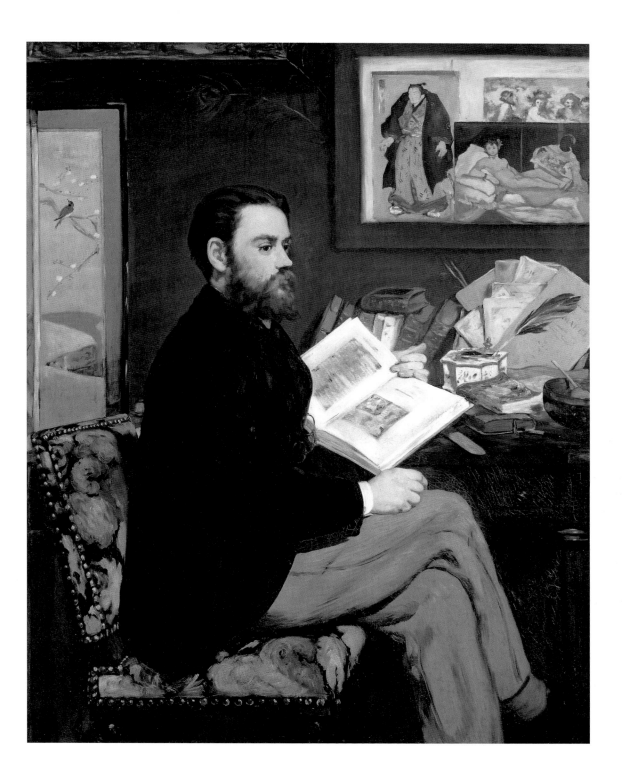

Édouard Manet, **Portrait of Émile Zola**, 1868,
oil on canvas, 57.7 x 44.9 in. (146.5 x 114 cm), Musée d'Orsay, Paris

JAMES MCNEILL WHISTLER
Arrangement in Grey and Black No. 1 (Whistler's Mother)

"Jemie [James Whistler] had no nervous fears in painting his Mother's portrait for it was to please himself and not to be paid for in other coin, only at one or two difficult points when I heard him ejaculate 'No! I can't get it right! It is impossible to do it as it ought to be done perfectly!' I silently lifted my heart [...] as I observed his trying again, and oh my grateful rejoicing in spirit as suddenly my dear Son would exclaim, 'Oh Mother it is mastered, it is beautiful!' ..." (Anna Whistler on sitting for her son James's *Arrangement in Grey and Black*, 1871)

Whistler's Mother is an iconic image. At first glance, it has a sentimentality that has both appealed to American popular culture and inspired parody. Yet its "traditional" qualities obscure the avant-garde nature of the work and of the artist who made it. James Whistler was a leading rebel in late nineteenth-century Europe. His paintings and watercolors rejected the rules of academic Western art, becoming known for their ethereal atmosphere and their novel explorations of composition and color. And though *Whistler's Mother* is a relatively early example of his work, it already reveals much of his mature style.

Anna Whistler was a conservative, devout woman who likely disapproved of her son's bohemian lifestyle. Yet she spoke fondly of her time as James's sitter in 1871. While making the image, Whistler appears to have focused more on its form than on its subject. One can see in it the artist's admiration for Japanese prints. Whistler employs an asymmetrical, "Japanese" composition of carefully placed shapes. The rectangular forms of the wall pictures and patterned drapery set off the gently curving shape of Anna's torso and upper legs. The work also shows Whistler's interest in unified color schemes, here represented by shades of gray and black; while Anna's lace and handkerchief reveal Whistler's ability to capture materials with the sketchiest of brushstrokes.

Whistler's original title for the work was simply *Arrangement in Grey and Black*. Yet the finished piece may have exceeded his intentions for it. Anna's quiet, solemn posture and face capture the "Puritan" spirit of early America. Whistler himself later admitted that the work told the "story of his soul" more effectively than most of his other creations.

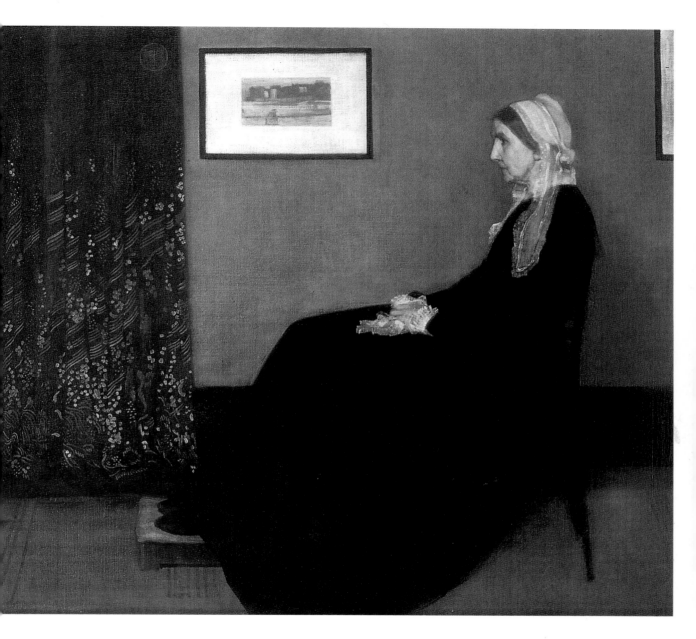

James McNeill Whistler, **Arrangement in Grey and Black No. 1 (Whistler's Mother)**, 1871, oil on canvas, 56.8 x 63.9 in. (144.3 x 162.5 cm), Musée d'Orsay, Paris

85

EDGAR DEGAS
Portrait of Mary Cassatt

1880–84

"I particularly want to get rid of the portrait Degas made of me which is hanging in the room beside my drawing room (my studio) [...] I don't want to leave this portrait by Degas to my family as one of me. It has some qualities as a work of art but it is so painful and represents me as such a repugnant person that I would not want anyone to know that I posed for it. [...] If you think my portrait saleable I should like it sold to a foreigner and particularly that my name not be attached to it."
(Mary Cassatt, on her portrait by Edgar Degas, 1912)

Mary Cassatt and Edgar Degas had much in common. They both came from well-to-do families and they both rebelled against their families' wishes in pursuing art careers. By the 1870s, their work came to feature similar qualities—an emphasis on expert draftsmanship, subtle expressions of character, and impressionistic renderings of daily life in Paris. The two began a lifelong friendship at this time, with Degas inviting Cassatt to exhibit her work at an early Impressionist exhibition in 1879. Degas also created a series of portraits showing Cassatt at the Louvre Museum and other social gathering places. The portrait shown here dates from the 1880s and is likely unfinished. Yet it shows many qualities of Degas's mature art. Cassatt looks outward from an obscured angle, and the overall depiction of space feels warped and flattened. This compositional technique reflected Degas's interest in Japanese art, and it gives his work a restless energy. The rapidly applied brushstrokes also lend vitality to the portrait, making the chairs and Cassatt's hat seem to pulsate on the canvas. Other areas of the canvas are energized by Degas's expressive, jagged splashes of color: whites, greens, and browns. Amidst all of this activity is Cassatt's red-toned face, alert and focused in its expression.

Years after the portrait was created, Cassatt wrote to her and Degas's art dealer, Paul Durand-Ruel, indicating that she was dissatisfied with the portrait. However, contemporary photographs of Cassatt suggest that her features were depicted with reasonable fidelity. Today, the work represents an elegant expression of a relationship between two great portraitists, and of the growing role of women artists during the nineteenth century.

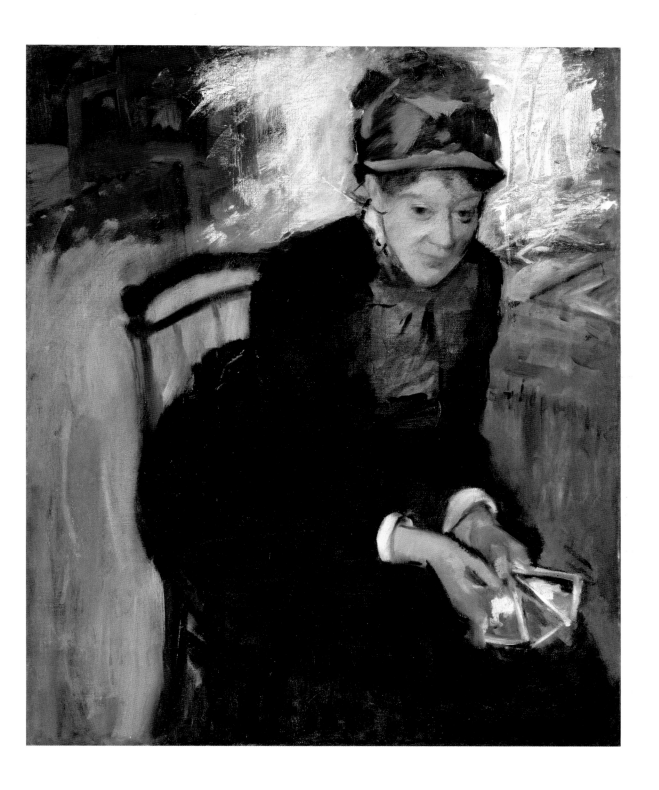

Edgar Degas, **Portrait of Mary Cassatt**, ca. 1879–84,
oil on canvas, 28.8 x 23.6 in. (73.3 x 60 cm), National Portrait Gallery, Washington, DC

JOHN SINGER SARGENT
Madame X

During the late nineteenth century, rapid economic growth in the United States spawned an entire generation of wealthy American tourists and expatriates. Many of them became thoroughly integrated into the European aristocracy. Young American artists, too, reveled in Europe's more relaxed, sophisticated cultural environment. One of those artists was John Singer Sargent. His family had moved to Europe before his birth, and his mother instilled in him an artistic passion. Sargent was blessed with brilliant natural gifts for portraying materials, textures, and atmosphere on canvas, as well as capturing the spontaneous expressions of his subjects. By the early 1880s, these gifts had made him Europe's most precocious and sought-after portraitist. Not surprisingly, many of his commissions came from other expatriate Americans.

The most scandalous of these commissions involved Virginie Avegno, a leading American socialite in Paris. Born in New Orleans, she had moved with her family to Paris after her father's death in the U.S. Civil War. Virginie married a wealthy Parisian banker, Pierre Gautreau, and quickly achieved celebrity status in French high society for her stylish looks and personality. After meeting Madame Gautreau in 1882, Sargent was so inspired by her beauty that he urged her family to let him paint her portrait. Gautreau conceded in 1883, and the painting was finished the following year.

Virginie Gautreau's figure stands out dramatically against a nearly formless background. Her dramatic pose is both classically elegant and vaguely risqué. Sargent perfectly captures the sumptuous velvet and silk of her low-cut evening dress. But it is her supple, bluish-tinted skin and provocative sideways glance that lend her a look of mystery and passion. Sargent portrayed Gautreau so effectively, in fact, the picture caused a scandal when it was first exhibited. Her identity (and less than demure character) was clear to many knowledgeable viewers, even though the picture's official title was *Madame **** (later *Madame X*). All of this was too much for Paris's nineteenth-century elite, and Gautreau was forced to abandon society life for a time. Sargent, too, received heavy criticism, to which he responded by moving his studio from Paris to London in 1886.

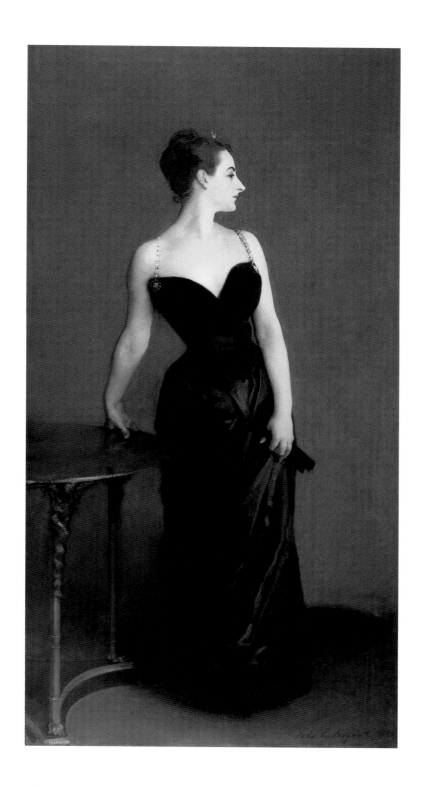

John Singer Sargent, **Madame X**, 1883–84,
oil on canvas, 82.1 x 43.2 in. (208.6 x 110 cm), Metropolitan Museum of Art, New York

PAUL CÉZANNE
Madame Cézanne in a Red Dress

1888–90

"In his portraits [...] the master painter (Paul Cézanne) was hardly concerned with *choosing* a model. He painted the first willing person he found nearby: his wife, his son, and more often simple people, a ditch digger, a milkmaid, in preference to a dandy or to sophisticated people whom he hated for their corrupt taste and worldly duplicity."
(Painter and art critic Émile Bernard)

As Émile Bernard wrote in his 1904 article for the French magazine *L'Occident,* Paul Cézanne never worried much about his choice of model. The master's portraits, in fact, rarely ever focused on the personality of the sitter. These images explored the same artistic goals as his landscapes and paintings of fruit did. They were, primarily, studies of composition and form. Cézanne deliberately built up his images from small, patch-like strokes of color. For him, each individual brushstroke had to be carefully considered before being placed on the canvas, in order to construct the perfect blend of colors and shapes. This painstaking method enabled him to create his own version of the natural world on canvas—a world that had both geometric precision and a palpable, organic quality.

So in this portrait of his wife, which Cézanne set in his Paris apartment, the figure of Mme. Cézanne is given the same importance as the yellow chair, the floral drapery, and other elements in the room. She is merely an object in the composition. Paul intentionally de-emphasizes her face, giving it a blank, impenetrable expression. He leads the viewer's eye to other details, such as the curving forms of the red dress, which seem both energetic and weighty. This energy extends to the swirling floral patterns in the drapery and chair and to his wife's slightly tilted, off-center position and the wainscoting behind her.

Cézanne's portraits came to exert a great influence over many modern painters. Artists such as Pablo Picasso would take even more liberties with their sitters' image—breaking apart the human body into expressive shapes and colors. For these artists, as for Cézanne, the exploration of personality had been superseded by the exploration of form.

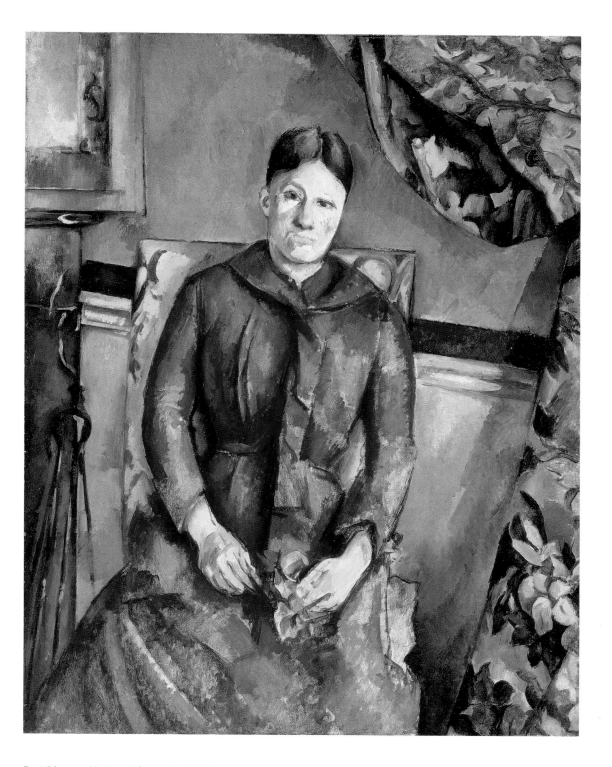

Paul Cézanne, **Madame Cézanne in a Red Dress**, 1888–90,
oil on canvas, 45.8 x 35.2 in. (116.5 x 89.5 cm), Metropolitan Museum of Art, New York

VINCENT VAN GOGH
Portrait of Dr. Gachet

"I *should like* to paint portraits which would appear after a century to the people living then as apparitions. By which I mean that I do not endeavor to achieve this by a photographic resemblance, but by means of our impassioned expressions—that is to say, using our knowledge of and our modern taste for color as a means of arriving at the expression and the intensification of the character. So the portrait of Dr. Gachet shows you a face the color of an overheated brick and scorched by the sun, with reddish hair and a white cap, surrounded by rustic scenery with a background of blue hills; his clothes are ultramarine—this brings out the face and makes it paler, notwithstanding the fact that it is brick-colored. His hands, the hands of an obstetrician, are paler than the face. Before him, lying on a red garden table, are yellow novels and a foxglove flower of a somber purple hue." (Vincent van Gogh, from an 1890 letter written to his brother Theo)

Both in his words and his paintings, Vincent van Gogh revolutionized the art of portraiture. Van Gogh was inspired by the ideas of French Impressionism, which used color to capture the fleeting quality of light and atmosphere on canvas. Van Gogh, however, saw how color could be manipulated to capture the profound depths of human psychology—the "intensification of the character."

Van Gogh painted the portrait of Dr. Gachet in 1890, the final year of his life. Gachet was the physician who cared for van Gogh in Auvers, France, after the artist was released from a mental hospital in nearby Saint-Remy. Despite Van Gogh's fragile state, he and Gachet developed a friendship. The doctor was an artist himself and likely had sympathy for Van Gogh's emotional struggles. The portrait of Gachet depicts a complicated man who is, in the artist's words, "sad and yet gentle, but clear and intelligent." These qualities are captured not merely in the facial expression, but also in the "somber" curves and colors of the foxglove plant and the slightly disheveled yet energetic shapes of the coat. Van Gogh's portrait nevertheless also captures the artist's own personality. Rugged, deep blue brushwork give the entire scene an intensity that hints at his struggles with mania and depression. Portraits such as *Dr. Gachet* would make Van Gogh the grandfather of twentieth-century Expressionist art.

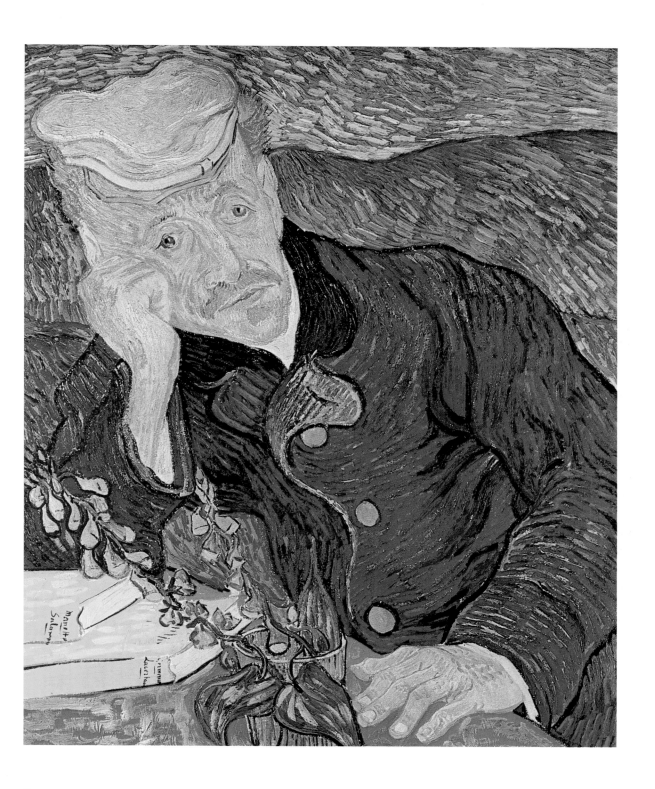

Vincent van Gogh, **Portrait of Dr. Gachet**, 1890,
oil on canvas, 23.4 × 22.0 in. (67 × 56 cm), private collection

HENRI MATISSE
The Green Stripe (Portrait of Madame Matisse)

"I cannot copy nature in a servile way, I must interpret nature and submit it to the spirit of the picture. From the relationship I have found in all the tones there must be a living harmony of colors, a harmony analogous to that of a musical composition."
(Henri Matisse, from his 1908 essay *Notes of a Painter*)

Henri Matisse helped redefine the use of color in European art. In the first years of the twentieth century, he developed an analytical understanding of color— partly influenced by his experiments with Pointillism, which "reconstructed" the effects of natural light by building images with colored dots or blotches. His painted faces, flowers, and objects were defined by supple brushstrokes of pure hues. But these colors and lines were not meant to represent the natural effects of light and form. Instead, they helped Matisse create an alternate reality on canvas.

Matisse's early style can be seen in a famous portrait of his wife, now known as *The Green Stripe*. The work dramatically simplifies Mme. Matisse's features and sets her image against a collage of color fields. Yet through his choice of color and the way it is applied, Matisse gives this two-dimensional image a subtle sense of light and shade and a feeling of natural depth. Mme. Matisse's face is divided by a dramatic green line down the forehead, nose, and chin. This stripe acts as a shadow line dividing the two sides of the face, yet neither side employs traditional European shading techniques. The color scheme alone creates the illusion of light and dark. Moreover, Matisse's vigorous brush- strokes produce abstract patterns that give the face a slightly three-dimensional quality. The face even captures some of Mme. Matisse's independent "spirit." Yet the subject of this portrait is not so much the sitter, but the art of painting itself— as redefined by Matisse.

Works such as *The Green Stripe* confounded critics of the time, who referred to them as "Fauvist"—or the art of "wild beasts." Yet Matisse's careful experiments with color and form would inspire later generations of modern artists, who continued to break down and redefine the meaning of art and art technique.

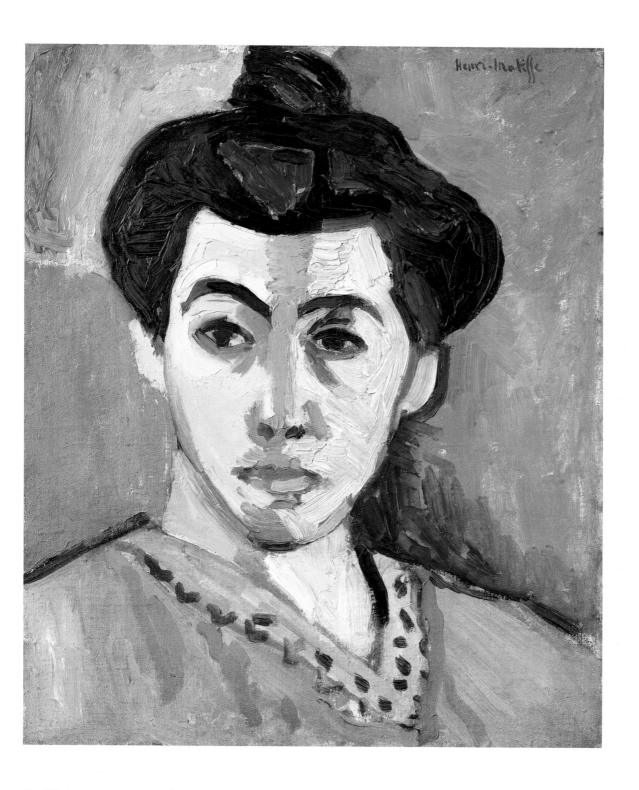

Henri Matisse, **The Green Stripe (Portrait of Madame Matisse)**, 1905,
oil on canvas, 15.9 × 12.8 in. (40.5 × 32.5 cm), Statens Museum for Kunst, Copenhagen, Denmark

GUSTAV KLIMT
Adele Bloch-Bauer I

The paintings of Gustav Klimt, though highly individual, were part of a larger art movement that swept Europe and North America in the late nineteenth century. Branches of the movement acquired such names as "Arts and Crafts," "Art Nouveau," and "Jugendstil," but they all developed as a reaction to the West's increasing dependence on industrialization and machine-made products. Progressive nineteenth-century artists sought to restore traditional, handcrafted techniques. They also sought inspiration from organic forms in nature and from the "primitive" imagery of medieval Europe and other pre-Renaissance cultures. When artists like Klimt combined all these "antique" influences, they produced an art that was remarkably—and sometimes shockingly—modern in appearance.

Klimt's best-known works are his lavish society portraits, especially those from his "golden age": 1897 to 1907. In the 1907 portrait of Adele Bloch-Bauer, Klimt transforms Adele's dress into a river-like swathe of glittering ornamental forms. These forms include the Egyptian eye, the ancient Greek spiral, and the Byzantine mosaic square. Adele's delicate head and hands, as well as her extravagant necklace, seem to emerge slowly out of this primordial bath, which in turn appears to dissolve into the stylized golden wall and green floor of the "background." Klimt portrays her face with striking, almost photographic accuracy, but its expression is left blank and impenetrable. Adele's image and "personality" have been absorbed into Klimt's overall composition, one that achieves a playful balance between geometric and organic shapes and between two-dimensional and three-dimensional space.

Adele Bloch-Bauer I embodies the vital role that enlightened patrons played in the development of modern art. Ferdinand Bloch, Adele's husband, was a wealthy Jewish executive in the sugar industry. His patronage helped keep Klimt solvent during a time when the artist was no longer receiving public commissions. Bloch's estate was later confiscated by the Nazis during World War II and sold to Vienna's Belvedere Gallery in 1942. In 2006, after decades of legal battles, Ferdinand's descendants finally recovered the Bloch-Bauer portrait from Austria. The work was eventually sold to the Neue Gallery in New York City.

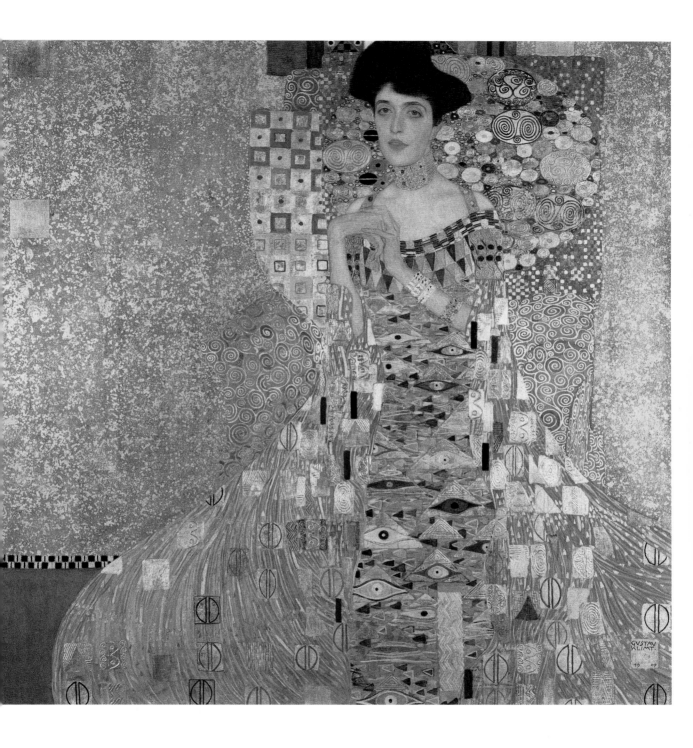

Gustav Klimt, **Adele Bloch-Bauer I**, 1907,
oil, silver, and gold on canvas, 55 × 55 in. (140 x 140 cm), Neue Gallery, New York

GABRIELE MÜNTER
Marianne von Werefkin

"After a short period of agony I took a great leap forward, from copying nature — in a more or less Impressionist style — to feeling the content of things — abstracting — conveying an extract.

It was a wonderful, interesting, enjoyable time, with lots of conversations about art with the 'Giselists,' who were full of enthusiasm. [...] All 4 of us were keenly ambitious and each of us made progress. I did a whole heap of studies. There were days when I painted 5 studies (on 33 x 41 [cm] sheets of cardboard) and many when I managed 3 and a few when I didn't paint at all. We all worked very hard."
(Gabriele Münter on painting with Wassily Kandinsky and the "Giselists," Marianne von Werefkin and Alexei Jawlensky, ca. 1908)

Gabriele Münter was among a small group of women in the early 1900s who had the talent and financial independence to explore a career in modern art. In 1902, she began studying under Russian expatriate Wassily Kandinsky at the progressive Phalanx school in Munich. Münter and Kandinsky soon became lovers and artistic partners, helping to establish a series of artists' communities in the nearby town of Murnau. Together with two other Russian-born painters, Alexei Jawlensky and Marianne von Werefkin, they explored new ways of abstracting natural forms on canvas. For Kandinsky, these experiments would lead to an abstract art devoid of natural "representation." Münter's style, however, would never completely abandon the human figure.

One of Münter's best works from this period is her 1909 portrait of Marianne von Werefkin. This tiny image is produced on a cardboard sheet, a "canvas" she often employed to tinker with new ideas. Von Werefkin's body is abstracted into a triangular shape, similar to the alpine peaks that graced Murnau's surrounding landscape. Her head and hat are also reduced to rounded planes of color—vivid hues that Münter uses to express emotions. These colors reveal the influence of Henri Matisse and Fauvist art, which Münter and Kandinsky would have seen on their trips to Paris. The painting also achieves a vivid energy through Münter's thick, confident brushstrokes. And despite the painting's abstractions, Münter is able to capture something of von Werefkin's energetic character.

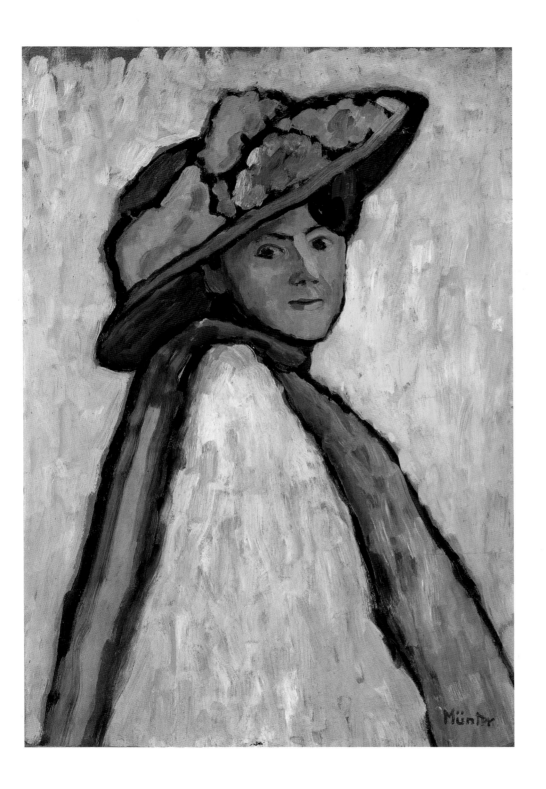

Gabriele Münter, **Marianne von Werefkin**, 1909,
oil on cardboard, 31.9 x 21.6 in. (81 x 55 cm), Lenbachhaus, Munich

EGON SCHIELE
Self-portrait with Physalis

"I, Eternal Child, brought offerings to others, / to those whom I pitied, to those who were far away / and did not see me, the seer. / I brought gifts, sent eyes and flickering tremulous air / to meet them, fanned out roads before them, / easily travelled and — did not speak. / Before long, some recognized the silent language / of the one who looks inside and then / did not ask questions anymore." (From a 1911 poem by Egon Schiele)

Egon Schiele's Expressionist art was revolutionary for the way it captured the human body—and human sexuality—with an earthy, almost tortured openness. Schiele's bodies are often emaciated and twisted in appearance. As such, they foreshadow the images of death in the trenches of World War I and the concentration camps of World War II. But Schiele was, first and foremost, a master of portraying individual human emotion, even in the works that avoided stylized deformities.

Like many Expressionists in Germany and Austria, Schiele worked extensively with the human portrait—especially his own. The self-portrait shown here captures Schiele in a calmer, more reflective mood. Yet the face is still vibrantly energetic, revealing Schiele's mastery of elegant lines, expressive brushwork, and bold, aggressive modeling and color. The artist stares obliquely at the viewer with a penetrating yet sympathetic gaze, almost as if sizing up a sitter during a portrait session. Schiele's image also incorporates the natural world. As a protégé of Gustav Klimt, Schiele was part of the aesthetic movement that valued the role of nature in art. Schiele's images of trees and plants have the same flattened, expressive power as Klimt's verdant landscapes. In this portrait, Schiele's physalis (or Chinese lantern plant) seems to grow directly out of his own body. Its spindly branches and quivering, deep red leaves reflect the passionate, sensitive character of the artist himself, the "silent language" that he brings to the viewer.

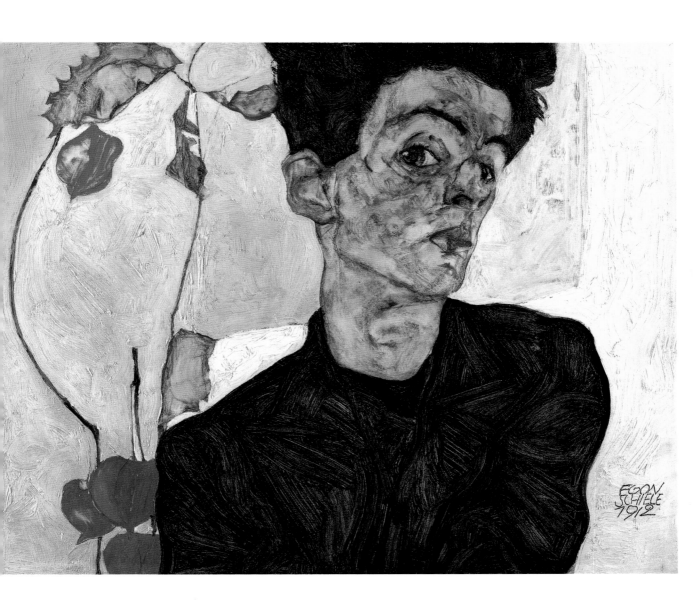

Egon Schiele, **Self-portrait with Physalis**, 1912,
oil and opaque color on wood, 12.7 x 15.7 in. (32.2 x 39.8 cm), Leopold Museum, Vienna

AMEDEO MODIGLIANI
Chaim Soutine

"A born psychologist, perceptive and subtle, he had by this time [just before the war] found his true path. He read the character of someone near him very accurately and quickly. This psychological gift was such that you could say his sitters resembled their portraits rather than vice versa. He underlined and exaggerated the characteristics of his sitters and brought out what was hidden by secondary and subsidiary features." (Cubist painter Léopold Survage on Modigliani's working method)

Amedeo Modigliani was the archetypal bohemian artist. He spent nearly all of his mature career in the seedy, ethnically diverse Montparnasse district of Paris, rarely accepting much money for the works he was able to sell. Modigliani was physically attractive, but he was usually photographed with strewn hair and disheveled clothes. And like many later bohemians, this rough exterior hid a widely read, immensely cultured mind.

Modigliani's own bohemian contradictions were embodied in his portrait of Chaim Soutine. Modigliani had a fondness for this scruffy young Belorussian painter, who was developing his own avant-garde style. Both men came from financially stressed Jewish families, and Montparnasse was the one area of Paris where they could afford to live. And like Modigliani, Soutine was using Expressionist techniques to capture the essence of Paris's cultural underground. These artistic and cultural affinities between the two men are revealed in Modigliani's portrait. The subject is placed in a stark, somber-colored room with filthy walls and cheap furniture—a look matched by the sloppily dressed sitter. But underneath the rough edges, one can see Modigliani's mastery of line and expression. The torso, neck, and face are abstracted into elegant curving forms— forms that have an effective sculptural quality. Soutine's facial features, though slightly contorted and "exaggerated," evince an alert, probing, intelligent character: a youthful artist making his way in a foreign city.

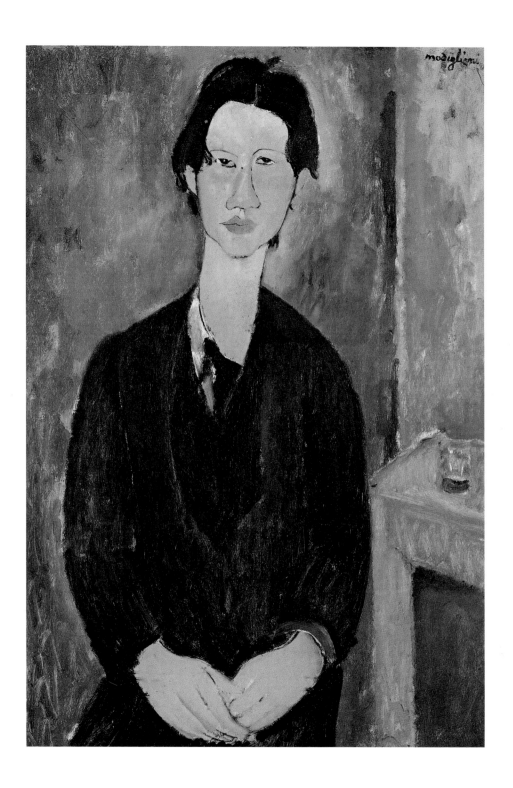

Amedeo Modigliani, **Chaim Soutine**, 1917,
oil on canvas, 36.1 x 23.5 in. (91.7 x 59.7 cm), National Gallery of Art, Washington, DC

JOAN MIRÓ
Portrait of a Young Girl

1919

"I was thoroughly overwhelmed by Paris. I was completely disoriented for one entire year. So much so that I tried to go to an art school and I couldn't even draw a line. I'd set myself up in front of the models but I couldn't draw a thing. I'd lost the hang of it, and I didn't get it back again until I went back to Mont-roig the following summer, and I immediately burst into painting the way children burst into tears."
(Joan Miró, from a 1928 interview with Catalan journalist and novelist Francesc Trabal)

The Catalan painter Joan Miró is best known for works that feature curving, Surrealist shapes abstracted from nature. Yet like Pablo Picasso, Marc Chagall, and other early masters of modern art, Miró began his career exploring more traditional figural subjects. The young painter spent time each year on his family's rural estate in Mont-roig del Camp. The works he painted there captured both the landscape and lifestyle of his region's farming communities. Fittingly, Miró's style during this time owed much to folk art. It also drew from Catalonia's unique medieval church paintings, which featured flattened bodies and boldly expressive shapes and colors.

Among the most popular works from Miró's time in Mont-roig are his portraits, including his *Portrait of a Young Girl* from 1919. The artist based his image on a four-year-old girl named Consol Boquera, who was the daughter of a local farmer. Miró renders his subject's simple blouse and tissue-paper hair in delicate hues and forms. Her weightless body seems to float against the darkened background, almost like the sea creatures that inhabit Catalonia's marine environment. Yet Miró also gives the girl an intense, exotic expression. Her large, gracefully curved eyes stare piercingly at the viewer. They resemble the eyes of Christ figures from Catalan Romanesque art. As Miró's career progressed and his art became more abstract, he would continue to incorporate elements seen in *Portrait of a Young Girl*—elements that express the history and natural environment of his homeland. As such, *Young Girl* reveals how the portrait format could help modern painters begin their journey away from the realism of traditional European art.

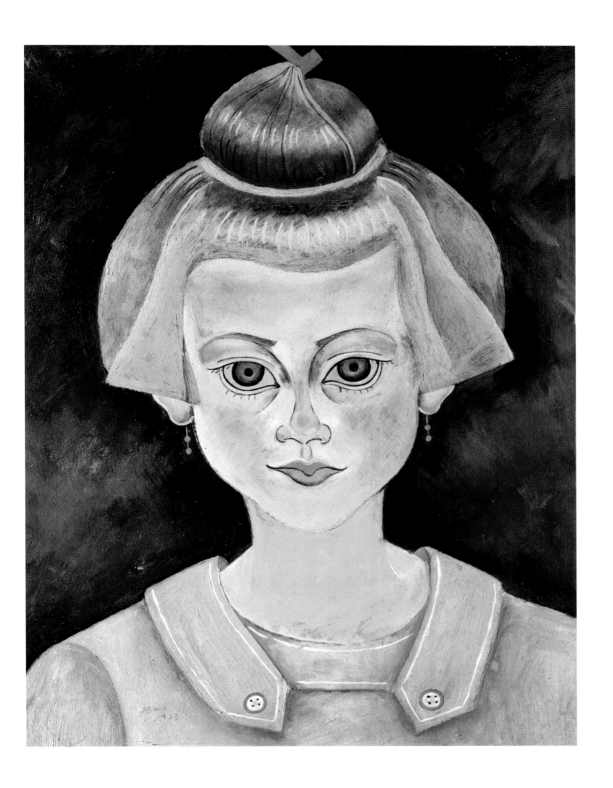

Joan Miró, **Portrait of a Young Girl**, 1919,
oil on paper on canvas, 13.7 x 10.6 in. (34.8 x 27 cm), Fundació Joan Miró, Barcelona, Spain

MAX BECKMANN
Self-portrait in a Tuxedo

"I think the reason why I love painting so much is because it forces me to be factual. There is nothing I hate as much as sentimentality. The stronger and more intense my will to capture the ineffible things in life becomes, the heavier and deeper the trauma of our existence burns within me [...] the colder does my will become to grab this eerie, jolting monster of vitality and lock it up in crystal-clear, sharp lines and surfaces ..." (Max Beckmann, from his 1918 text "Ein Bekenntnis" [A Confession])

Perhaps no other German artist did more to advance the popularity of modern art than Max Beckmann. He not only produced a massive output of paintings, drawings, and prints, but also became a prominent teacher and lecturer. Beckmann developed a broad, sophisticated appreciation for the modern art of his youth—especially Manet and the Impressionists—as well as the work of older masters such as Matthias Grunewald and Théodore Géricault. He combined these influences with his own expressive brushwork and his facility for expressing inner human emotions (the "trauma of our existence") to concoct a highly personal style.

For Beckmann, a key goal of his art was the greater self-understanding he felt was necessary before one could understand and depict the outer world. This search for the self, or the "Ego," often took the form of self-portraits. The example here shows how Beckmann could alter his own image to express the contradictory aspects of his nature. The artist stares boldly at the viewer, almost as an actor on stage. The deep black tuxedo and the "sharp" vertical lines of the background make his erect figure and its massive bulldog head stand out boldly. Yet this masculine bravado is counteracted by the "effeminate" position of the hands and right arm. Beckmann also uses dramatic shading to give his expression a hint of vulnerability and self-doubt.

Self-portrait in a Tuxedo became an immediate sensation in 1920s' Germany. Remarkably, the Nationalgalerie in Berlin purchased the work in 1928 and opened up an entire Max Beckmann wing. His image would also have its equivalent in German popular culture—especially in the androgynous photos of Marlene Dietrich wearing white tie and tails.

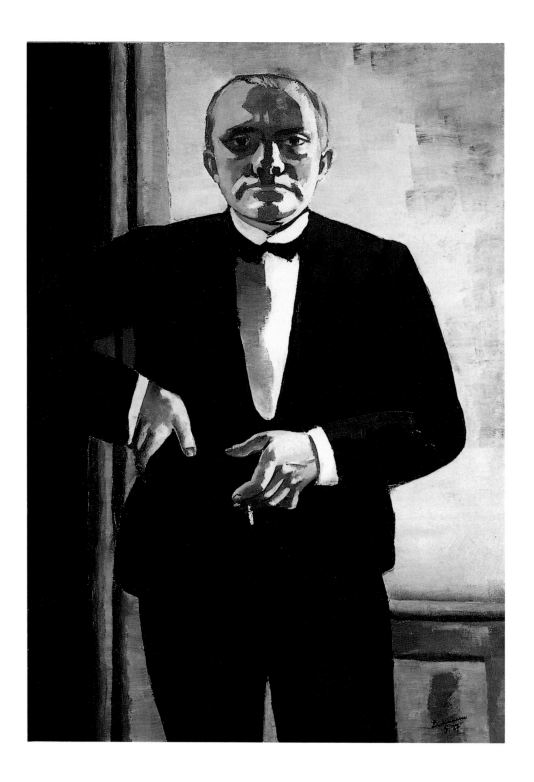

Max Beckmann, **Self-portrait in a Tuxedo**, 1927, oil on canvas,
54.9 x 37.6 in. (139.5 x 95.5 cm), Busch-Reisinger Museum, Harvard University, Cambridge, Massachusetts

FRIDA KAHLO
Self-portrait with Necklace

The art of Frida Kahlo revolved around the self-portrait. She once asserted: "I paint myself because I am so often alone and because I am the subject I know best." Kahlo was strong-willed, impulsive, and bisexual. She was also trapped in a conservative Mexican culture highly suspicious of independent women. Her marriage, too, was emotionally complicated—both nurturing and destructive. Her husband, the Mexican muralist painter Diego Rivera, had a deep affection for her and fostered her art. Yet the two partners were openly unfaithful to each other, creating a tension in their relationship that became unbearable. This emotional pain was often reflected in her self-portraits, which occasionally showed her body ripped apart and her bleeding heart and veins exposed on her chest.

Yet Kahlo could also use her image to express assuredness and emotional renewal. In 1933, she and Rivera were living in Michigan, while Rivera worked on a mural for the Detroit Institute of Arts. The period had been a difficult one for her, as she had suffered a miscarriage the year before, but Kahlo was able to turn to her painting as a means of battling her depression. She was soon quoted in a *Detroit News* article, saying "It is I who am the big artist"—a playful jibe at her more famous husband.

Kahlo's *Self-portrait with Necklace* seems to reflect that playfulness and self-confidence. Her gaze is strong and intense, with only a hint of her formerly fragile state. Moreover, the work shows Kahlo's ability to combine elements and symbols in an exciting way. For example, the delicate lace on her shirt collar and the neatly pulled-back hair reflect her Catholic upbringing, while her strong facial features and the roughly cut, pre-Columbian jade beads on her necklace capture Mexico's ancient Mayan and Aztec traditions. Kahlo also uses her face to express the complex nature of her sexuality—with its "feminine" rouged cheeks and delicate eyes and "masculine" eyebrows and thin moustache. All of these striking visual juxtapositions would soon make Kahlo a darling of the Surrealist movement. Like them, Kahlo had a knack for eliciting thoughts and ideas "beyond" ordinary reality.

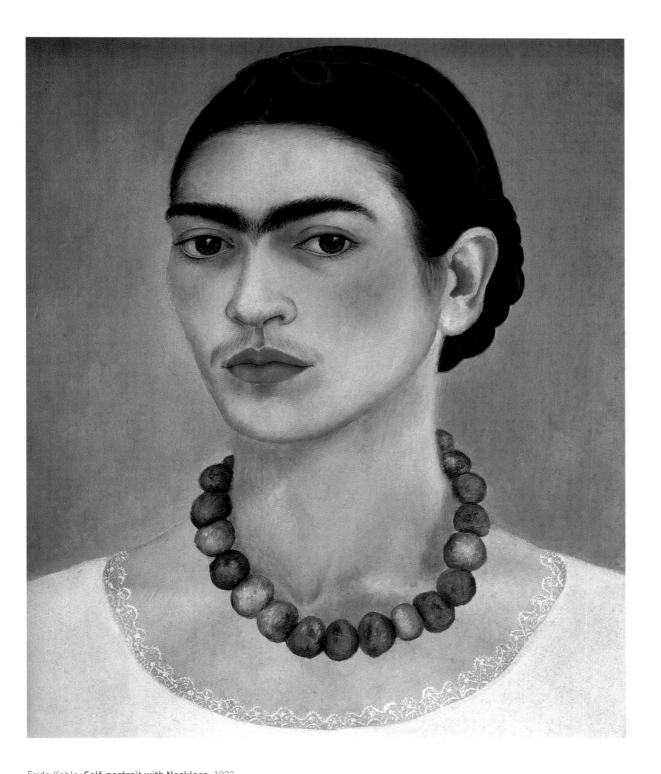

Frida Kahlo, **Self-portrait with Necklace**, 1933,
oil on metal, 13.5 x 11.5 in. (34.3 x 29.2 cm),
The Jacques and Natasha Gelman Collection of Modern and Contemporary Mexican Art, Cuernavaca, Mexico

PABLO PICASSO
Portrait of Dora Maar

"Picasso told me that one of the first times he saw Dora she was sitting at *Les Deux Magots*. She was wearing black gloves with little pink flowers appliquéd on them. She took off the gloves and picked up a long, pointed knife, which she began to drive into the table between her outstretched fingers to see how close she could come to each finger without actually cutting herself. From time to time she missed by a tiny fraction of an inch and before she stopped playing with the knife, her hand was covered in blood. He was fascinated ..." (Françoise Gilot on the legendary meeting of Pablo Picasso and Dora Maar)

Throughout his life, Pablo Picasso explored new ways to portray women on canvas. His images captured the complex, often difficult relationships he had with them. Picasso remained married to his first wife, Olga Khokhlova, from 1918 until her death in 1955, but spent much of that period with mistresses—from Dora Maar to Françoise Gilot. He portrayed all these women in a dramatic variety of styles, but the Dora Maar portraits are the best known and most admired.

Dora Maar, who was born Henriette Theodora Marković, became a noted Surrealist photographer in the early 1930s. Her style of photographic collage often depicted sinister, nightmarish worlds, but it was her fiery, artistic personality that attracted Picasso. This trait is reflected in the story of their first meeting, which is likely fictionalized in some of its details, and is also captured in Picasso's paintings of her.

The famous portrait shown here dates from 1937, after Maar and Picasso had moved in together. The work represents a synthesis of styles that Picasso had developed over the previous thirty years. One can see elements of his Cubist art in the way Maar's body appears broken up and reassembled into abstract shapes. It also reflects his experiments with Surrealist technique—the use of visual forms to suggest emotional or psychological states. The soft, rounded shapes in the face and shoulder contrast with the spiky, "knife-like" fingers and harsh, acidic colors, suggesting a character that is erotic and moody, strong-willed and unpredictable. Moreover, despite all of Picasso's modernist deformations, the portrait still resembles the real-life woman.

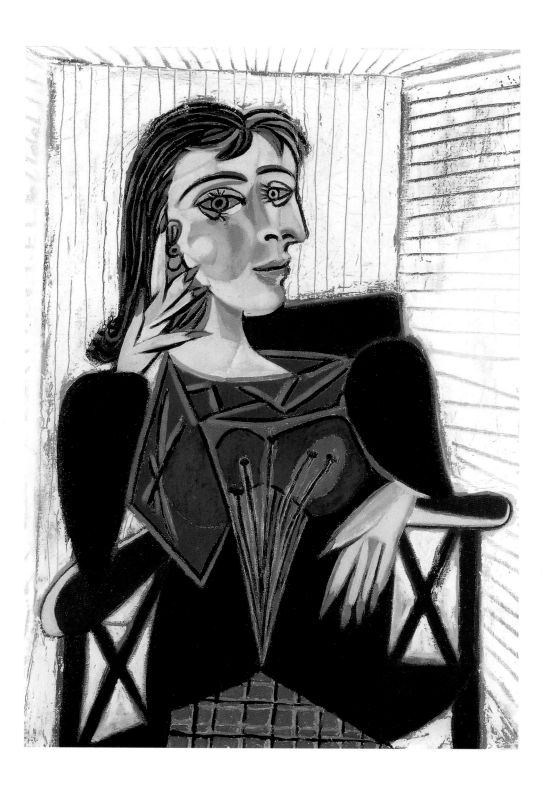

Pablo Picasso, **Portrait of Dora Maar**, 1937,
oil on canvas, 36.2 x 25.6 in. (92 x 65 cm), Musée Picasso, Paris

LEONORA CARRINGTON
Self-portrait

"The greatest difficulty was to find a disguise for the hyena's face. For hours and hours we sought an answer: she rejected all of my proposals. At last she said, 'I think I know a solution. You have a maid?'

'Yes,' I said, perplexed.

'Well, that's it. You will ring for the maid and when she enters we will throw ourselves upon her and remove her face. I will wear her face this evening in place of my own.'"
(Leonora Carrington, from her short story "The Debutante")

Leonora Carrington spent her childhood surrounded by the trappings of privilege: a grand country estate with landscaped gardens, horses, and toys. But as the only daughter of a conservative Irish family, she felt trapped in her idyllic cage. Carrington's early self-portrait uses the female hyena as a kind of alter ego. This creature also made an appearance in her short story "The Debutante," which tells of a reluctant debutante who visits a zoo and makes friends with a hyena. She then has the animal take her place at the debutante's ball, letting it "disguise" itself by killing her maid and wearing the maid's dead face as a mask.

For Carrington, the hyena character may have been used to harbor—and even embody—her own "savage" urges for spiritual independence.

Other elements in *Self-portrait* reflect Carrington's emotional struggles. The stark room suggests feelings of psychological torment, and the floating rocking horse and open window hint at a desire for escape from those feelings. Even Carrington's own image suggests psychological tension. The elegant jodhpurs and Victorian boots contrast with her wild, medusa-like hair—details that may represent her tug-of-war with the demure ideal of Victorian womanhood. In all, Carrington's *Self-portrait* shows how Surrealist art could "break apart" the human character into a poignant assemblage of objects and symbols.

Leonora Carrington, **Self-portrait**, 1937–38,
oil on canvas, 25.6 x 32 in. (65 x 81.3 cm), Metropolitan Museum of Art, New York

ANDY WARHOL
Turquoise Marilyn

"We can start the country over again from scratch. [...] Can you see the Blue Room with Campbell's Soup Cans all over the walls? Because that's what foreign heads of state should see, Campbell's Soup Cans and Elizabeth Taylor and Marilyn Monroe. That's America. That's what should be in the White House. And you would serve Dolly Madison ice cream. A, see yourself as others see you."
(Andy Warhol, from his 1975 book, *The Philosophy of Andy Warhol [From A to B and Back Again]*)

Since the development of photography in the 1800s, mechanically produced portraits have become a ubiquitous part of modern life: family snapshots replaced painted portraits in middle-class homes around the world, while the celebrity image became a chief market-ing tool for products of modern industry. In the 1960s, Pop Art confronted this commercial world more directly than any earlier art movement, and the leading Pop artist, Andy Warhol, appropriated the celebrity portrait for his own ends.

Warhol created an art form that combined cheap, mechanized processes and instantly recognizable commercial imagery. For his ironic portraits, he developed a modified silk-screen printing process. "With silk-screening," Warhol said, "you pick a photograph, blow it up, transfer it in glue onto silk, and then roll ink across it so the ink goes through the silk but not through the glue. That way you get the same image, slightly different each time. It all sounds so simple—quick and chancy. I was thrilled with it. My first experiments with screens were heads of Troy Donahue and Warren Beatty, and then when Marilyn Monroe happened to die that month (August 1962), I got the idea to make screens of her beautiful face."

The Marilyn portrait shown here represents one of those early experi-ments. Warhol's image is based on a 1953 publicity photo for the movie *Niagara*. But his screening technique gives the image a cheap, mass-produced look, with its faded details and the garish acrylic colors applied as "make-up" on Monroe's face. Warhol makes it clear that the Marilyn image itself is a deliber-ate construction by the movie industry. Yet the humor of that image is tempered by the real Marilyn's tragic fate—a fate Warhol knew, even in 1962, would be used to enhance her legend in the future.

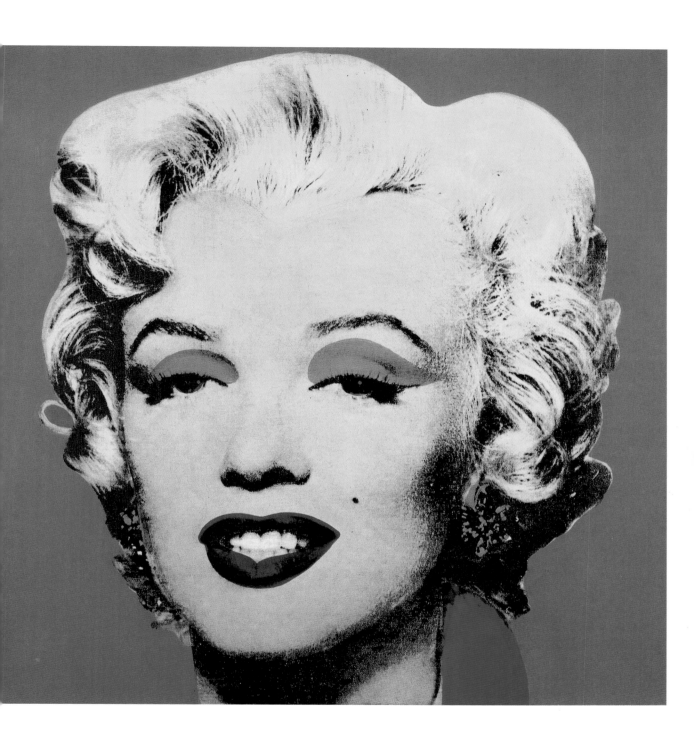

Andy Warhol, **Turquoise Marilyn**, 1964,
acrylic and silkscreen on canvas, 40 x 40 in. (101.6 x 101.6 cm), private collection

CHUCK CLOSE
Phil

"My position about it (the portrait *Phil*) is that I had to look at it in a different way. I was just an occasion for him (Chuck Close) to be a painter. [...] All of those people who were the images were just the images. I had very little vanity about it, but it was scary. It's scary to see yourself. The funny thing is that, if you look at that picture and look at a photograph of me taken at that time, I had a kind of tortured look. In fact, it took me about ten or fifteen years to grow up and look like that picture. I finally ended up looking like the painting." (Philip Glass on his portrait by Chuck Close)

During the 1960s, many artists attempted to find new ways of incorporating the mechanical image into modern art. Members of the Pop Art movement, including Andy Warhol and Roy Lichtenstein, often used industrial printmaking techniques to create imagery that mimicked or parodied commercial advertising. Other artists, such as Chuck Close, devised their own art-making processes. Close developed a meticulous technique of "reproducing" a photographic image on canvas. For this new art, he chose the most ubiquitous type of photograph: the portrait.

Close's 1969 portrait *Phil* depicts modernist composer Philip Glass. To create the image, he first took a snapshot of the sitter in his studio, making sure that the subject adopted an expressionless countenance. Afterwards, he would enarge the photo, score it with grid lines, and then painstakingly reproduce each "square" on the grid— piece by piece—on a huge, nine-foot-high canvas. The artist used an impressive variety of tools to apply and work his acrylic paint: spray guns, rags, erasers, razor blades, brushes, sponges, and even a modified commercial airbrush technique. Close chose the large-size canvas format so that he would be forced to create the painting in stages, making the work's details just as important as its overall composition. These details, which Close called the "little fuzzy things," engage the viewer as much as the overall image does.

Like the "portraits" by Cézanne and Picasso before him, Close's huge heads do not explore the subtleties of individual human character. The real subject of portraits such as *Phil* is the artistic process.

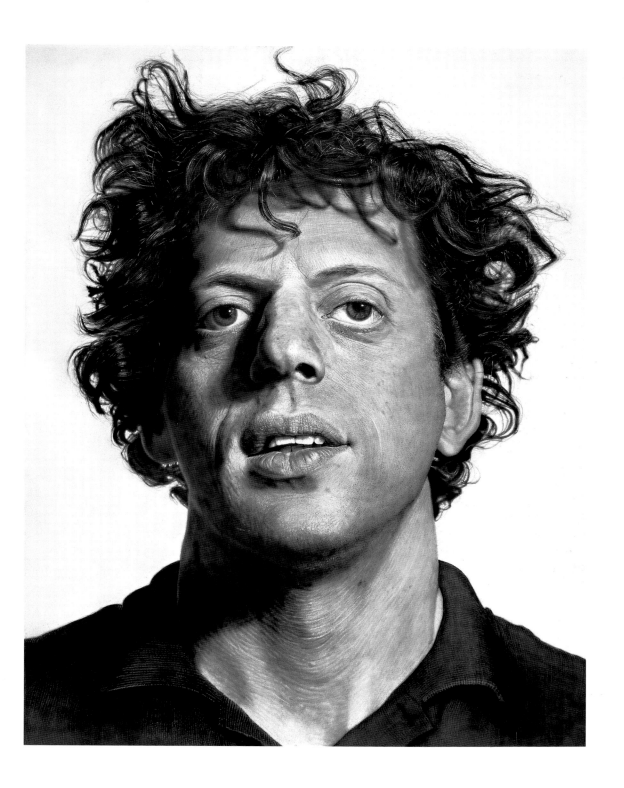

Chuck Close, **Phil**, 1969,
synthetic polymer on canvas, 108 × 84 in. (274.3 × 213.4 cm), Whitney Museum of American Art, New York

LUCIAN FREUD
Reflection (Self-portrait)

"Many people are inclined to look at portraits not for the art in them but to see how they resemble people. This seems to me a profound misunderstanding which is nevertheless very interesting. For instance, when I was working on a self-portrait a few years ago, I was very pleased when the cleaning lady said she thought it was me when she came into the room. I like it if people say very contradictory things about my work: 'It's very ugly.' 'It's very beautiful.' 'Do you get your models from an asylum?'" (Lucian Freud, from a 2005 interview)

Lucian Freud was the grandson of pioneering psychoanalyst Sigmund Freud. So it seems appropriate that he should become the most famous portraitist of the late twentieth century— a modern master at depicting psychological intensity on canvas. From the 1950s on, in fact, Freud devoted himself almost exclusively to portrait art.

Many of Freud's mature paintings employ a distinctive technique: the use of thickly applied brushwork in the depiction of human flesh. This method enables him to exaggerate the play of light and shade on the face and body, often making the skin look as though it is crumpling or disintegrating in front of the viewer's eye. The external "shell" of the face is thus visually stripped away to reveal the subject's inner psyche—or at least Freud's perception of that psyche.

As with many great portraitists of the past, Freud's most successful works are often his self-portraits. In his *Self-portrait* from 1985, the naked artist's intense gaze captures the attention of the viewer. Despite its intensity, that gaze is not easily decipherable. It seems to reveal the "contradictory things" that Lucian sought, suggesting both weariness and self-confidence, aggressiveness and passivity, all at the same time. Yet these contradictory traits also give the sitter a captivating individuality. As Freud himself would say, "I think a great portrait has to do with the way it is approached. [...] It's to do with the feeling of individuality and the intensity of the regard and the focus on the specific. [...] One of the things about all great art is that it involves you ..."

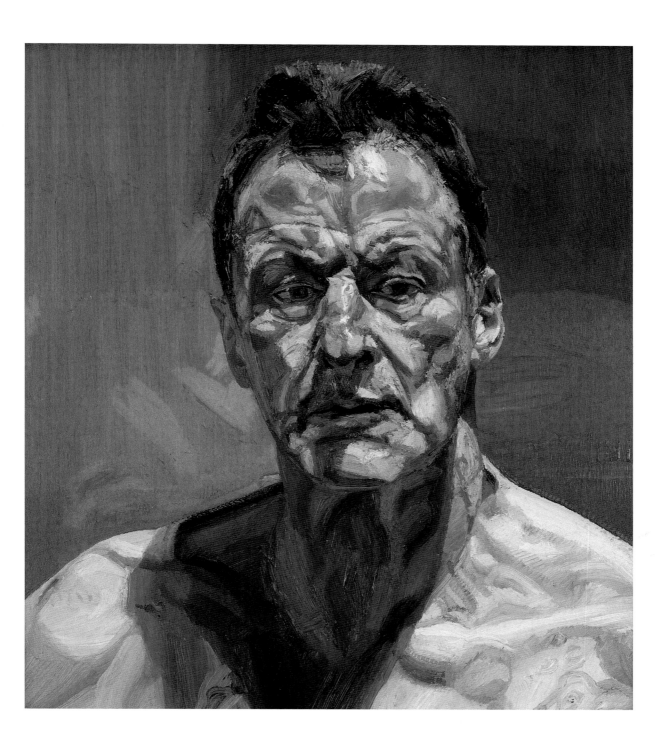

Lucian Freud, **Reflection (Self-portrait)**, 1985,
oil on canvas, 22 x 20 in. (56 x 51 cm), private collection

GERHARD RICHTER
Betty

"I don't think the painter need either see or know his sitter. A portrait must not express anything of the sitter's 'soul,' essence or character. Nor must a painter 'see' a sitter in any specific, personal way." (Gerhard Richter, from a 1966 interview)

Throughout Gerhard Richter's long career, he has never stopped experimenting. The German artist has dabbled in techniques ranging from painting to photography, from printing to the making of conceptual art objects. Many of his works, in fact, involve the creative merging of two or more techniques. Richter's heterogeneous imagery invites viewers to question the role of traditional artistic imagery in the "modern" world, as well as the ways in which art is meant to "communicate" with the viewer.

Richter has employed the portrait art form throughout his career. His portraits often begin life as causal photographs. For example, the original image for a series of works entitled *Betty* was a family snapshot taken in 1978. Betty, who is Gerhard's daughter, was eleven years old at the time. Richter meticulously reproduced the photograph as an oil painting in 1988. As with many of his

images, the artist's intentions are unclear. Not only is it uncertain what the sitter is doing, but the girl's face is completely hidden from view—preventing any exploration of "soul, essence or character." Instead, Betty seems to be staring at a void behind her, a void as "blank" as our impression of her. Some art historians have even argued that the background is actually one of Richter's early monochrome paintings. Thus the subject of *Betty* might not be the girl at all, but the "real" artwork she appears to be studying.

And yet despite her blankness, Betty rivets the viewer's attention. By actively denying us a "window" into the girl's personality, the artist heightens our curiosity about her. Richter also plays with our understanding of painterly beauty. The red floral pattern on Betty's outfit has the glossy look of a magazine advertisement (Richter himself called the work "kitschy colorful"). Richter nevertheless uses a lavish painting technique to produce the pattern, a technique normally associated with more aesthetic kinds of beauty. In all, Richter's *Betty* makes us contemplate the very notion of the portrait as an art form.

Gerhard Richter, **Betty**, 1988,
oil on canvas, 40.1 × 28.3 in. (102 × 72 cm), Saint Louis Art Museum, Saint Louis, Missouri

BIOGRAPHIES

ROBERT CAMPIN
(ca. 1375–1444)

Robert Campin spent much of his career in Tournai, which is now in Belgium. There, he joined the professional guild of painters in 1406. His workshop grew quickly, with talented apprentices who may have included Rogier van der Weyden. Along with Jan van Eyck, Campin helped develop the Early Renaissance style in Flemish art—an art that featured brilliant, saturated colors, intricately detailed renderings of materials and human figures, and depictions of realistic three-dimensional space. Campin was also among the first Europeans to create a naturalistic style of portraiture, often capturing the unusual or expressive everyday faces of his home city. Records indicate that Campin ran afoul of the law around 1430 and was banished from the city for a time. He nevertheless continued to paint until the end of his life.

JAN VAN EYCK
(ca. 1390–1441)

Jan van Eyck was likely born in the Flemish village of Maaseik. Records indicate that he was an apprentice painter in The Hague from 1422 to 1424. He settled permanently in Bruges around 1425, when he became court painter to Philip the Good, the duke of Burgundy. Yet Van Eyck's output was not restricted to Philip's patronage. He also received commissions from wealthy merchants who lived in Bruges. The greatest example of such work is the *Arnolfini Portrait* (1434), a strikingly realistic wedding portrait that may depict Italian merchant Giovanni Arnolfini and his wife. Van Eyck also worked with his brother Hubert on the masterful *Ghent Altarpiece* (1430–32), which includes the first naturalistic depictions of nudes in Flemish art.

PISANELLO
(ca. 1395–ca. 1455)

Pisanello was born Antonio di Puccio in Pisa. He likely spent his childhood in his mother's home city of Verona. Pisanello probably studied with the late Gothic painter and illustrator Gentile da Fabriano, whose work was known for its delicate facial expressions and flowing lines. Pisanello soon became an important fresco painter, creating major works in Verona's church of San Fermo and Rome's Basilica of St. John Lateran. But the artist is best known today for his smaller works, especially his portraits and his drawings of animals. These tiny masterpieces are highly detailed and biologically accurate, reflecting Pisanello's lifelong study of nature.

ROGIER VAN DER WEYDEN
(1399/1400–1464)

Rogier van der Weyden was born Rogelet de la Pasture in the city of Tournai, which is now part of Belgium. Little is known of his early life, but he appears to have studied under Robert Campin. He then settled permanently in Brussels in 1435, adopting the Dutch version of his name, Rogier van der Weyden. The artist's most characteristic surviving work is *The Descent from the Cross* (ca. 1435). In this dramatic altarpiece, Christ's lifeless body is depicted with smooth, sculptural realism. Other figures show Van der Weyden's flair for lavishly colored fabric and natural emotion. His art was widely admired in his own day. Records suggest that he received commissions from Spain and even traveled as far south as Rome.

PIERO DELLA FRANCESCA
(ca. 1416–1492)

Piero della Francesca was born in Borgo Santo Sepolcro, a town near Arezzo in northern Tuscany. Historians believe he was apprenticed to a local painter, Antonio d'Anghiari, during the 1430s. Piero earned one of his earliest commissions in Florence, where he was able to see and study the works of Masaccio, Donatello, and other early Renaissance masters. Over the course of his career, he would work for the most powerful men in Italy, including Sigismondo Pandolfo Malatesta in Rimini and Federico da Montefeltro in Urbino. Piero created masterful small works for these local rulers, including several ducal portraits. His grandest commission, however, was probably the cycle of frescoes he painted for Arezzo Cathedral in the 1450s.

SANDRO BOTTICELLI
(ca. 1445–1510)

Sandro Botticelli was born in Florence. He trained under Early Renaissance master Fra Filippo Lippi, and opened his own workshop by 1470. Over the next twenty years, Botticelli's art became a favorite of the Medici family. His style can be seen in the large-scale masterpiece *Primavera* (ca. 1482), an allegory of spiritual renewal. Here, Venus and the Three Graces seem to float in an idealized forest of ripe fruit trees. The figures' gracefully curved outlines are clearly visible, and their skin and shimmering dresses are modeled in low relief, giving the image a flattened spatial quality. Botticelli's flair for color and rich detail are also on display. In the 1490s, he became an adherent of the conservative friar Girolamo Savonarola, who castigated secular painting as profane, and Botticelli's output subsequently declined.

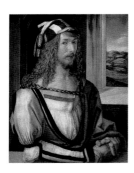 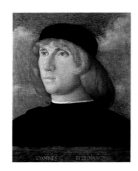

ALBRECHT DÜRER
(1471–1528)

Albrecht Dürer was born in Nuremberg, the son of a goldsmith. A precocious talent, he quickly mastered the arts of drawing, painting, and printmaking. After completing his studies, Dürer traveled to Italy in 1494, a highly unusual journey for a German artist at that time. While spending time in Venice, he absorbed the work of early Renaissance masters Giovanni Bellini, Antonio Pollaiolo, and Andrea Mantegna. Dürer then established his own workshop in Nuremberg in 1495. His biblical scenes still possess a vibrant sense of drama, as in his prints illustrating the apocalyptic visions of St. John in the New Testament. Dürer also produced brilliant drawings of nature, capturing animals and plants with energetic realism and anatomical detail, and he wrote influential treatises on anatomy and perspective.

GIOVANNI BELLINI
(ca. 1430–1516)

Giovanni Bellini was raised in a family of artists in Venice. His father, Jacobo, helped bring Renaissance painting to Venice, and his brother, Gentile, became a prominent international portraitist. Giovanni's own career began around 1450. His earliest images often featured religious scenes, depicting characters with expressive yet somewhat rigid modeling. By the late 1400s, however, his style had become softer and more subtle, with a rich, vibrant color palette. Giovanni received major commissions from the Venetian government, including the lucrative position of conservator of paintings at the Doge's Palace. He also became famous as a teacher, apprenticing two of the greatest High Renaissance Venetian masters: Titian and Giorgione.

LEONARDO DA VINCI
(1452–1519)

Leonardo da Vinci was born in the town of Vinci, near Florence. He was apprenticed in 1466 to Florentine painter Andrea del Verrocchio, where the young artist flourished. Da Vinci set out on his own in 1478. His first major commission, the *Adoration of the Magi* (1481), already reveals his mature style. The Virgin and Child are surrounded by a swirling mass of human figures, all depicted with individual expressions and gestures. In the background, a striking landscape features architectural ruins and battling horses. *Adoration* shows the artist's flair for capturing the vital essence of natural forms, and like many of his works, it remains unfinished. Leonardo's greatest gift was his capacity for experiment. His journals are packed with radically insightful drawings of nature, architecture, and transportation.

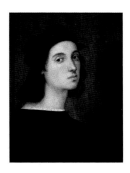

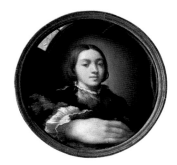

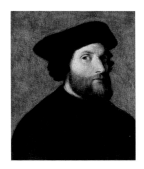

RAPHAEL
(1483–1520)

Raphael was born Raffaello Sanzio in Urbino, Italy, where his father, Giovanni, was court painter to the duke of Urbino. Raphael showed precocious talent as an artist, and he quickly became his father's assistant. Beginning around 1500, the young Sanzio worked with some of Italy's leading artists, including Pietro Perugino and Pinturicchio. He also spent time in Florence, where his art began to reflect the revolutionary naturalism of Leonardo da Vinci's work. By the time he settled in Rome in 1508, Raphael had developed his mature, lyrical style. His workshop would become the most successful in Rome, and he would lead the life of a wealthy aristocrat. Aside from painting, Raphael also designed Renaissance villas and made plans for the reconstruction of St. Peter's Basilica.

PARMIGIANINO
(1503–1540)

Parmigianino was born Girolamo Francesco Maria Mazzola in Parma, Italy. He began studying art under his uncles, who were professional muralists, and he quickly developed into a brilliant draftsman and painter. By the 1520s, he was creating graceful altar-pieces inspired by the artist Correggio and the new Italian Mannerist style. These works, which include *The Madonna with the Long Neck* (1534–40), feature sensual, elongated necks and limbs, delicate color, and emotive expressions. Other works, such as the self-portrait described above, show his interest in unusual optical effects. Parmigianino received major commissions in Parma and Rome during his career, which was ended prematurely in 1540, when the artist was only thirty-seven.

LORENZO LOTTO
(ca. 1480–ca. 1557)

Lorenzo Lotto was born in Venice, where he trained as a painter. The rebellious young artist was unable to establish a sufficient career in his highly competitive home city, so he spent most of his life working for brief periods in various cities across Italy, including Treviso, Bergamo, and Rome. While living in Bergamo, he painted a distinctive series of frescoes in the nearby town of Trescore. These works depict the lives of the saints with an array of fanciful details, such as floating ladders and human body parts transforming into plants. Lotto would also give his portraits an experimental, theatrical quality, most famously in his *Andrea Odoni*, where the sitter is surrounded by half-living antique sculptures.

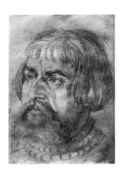

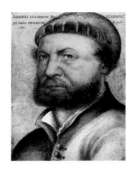

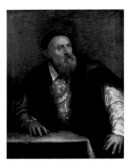

LUCAS CRANACH THE ELDER
(ca. 1472–1553)

Lucas Cranach the Elder was born in the German town of Kronach, in what is now northern Bavaria. He studied under his father, Hans, and probably with other local painters. By about 1505, the successful young artist had become a court painter in Wittenberg for Saxon ruler Frederick the Wise. He would retain that position for the rest of his life, even after Frederick's death in 1525. Cranach became famous for his portraits, his mythological scenes (often featuring nudes), and for his expressive woodcut prints. And even though Cranach's work would be associated with Protestant Lutheran culture, he also received commissions from the Catholic Holy Roman Emperor Charles V. When Cranach died in 1553, his son Lucas Cranach the Younger would continue painting in his father's style.

HANS HOLBEIN THE YOUNGER
(ca. 1497–1543)

Hans Holbein the Younger was born in Augsburg, in what is now southern Germany. He studied under his father, Hans Holbein the Elder, a gifted Early Renaissance painter and printmaker. The younger Hans moved to Basel in 1515, where he eventually set up his own workshop. Holbein's early masterpiece, the *Meyer Madonna* (1526), displays his genius for portraiture, especially in its depiction of the mayor of Basel, Jakob Meyer. The skin of Meyer's pudgy face and hands is rendered with almost photographic accuracy, as is his fur-lined coat, and Holbein also conveys Meyer's hard-headed, ambitious personality. Such imagery would appeal to the growing aristocratic class in England, where Holbein spent much of his career after 1526. He became official painter to King Henry VIII, capturing the Tudor court in striking detail and glowing colors.

TITIAN
(ca. 1490–1576)

Titian was born Tiziano Vecellio in Pieve di Cadore, in northern Italy. He moved to Venice as a child, eventually becoming apprenticed to the city's leading painter, Giovanni Bellini. Titan also worked with another great artist, Giorgione, before setting up his own practice by 1516. His mature works represent the height of Venetian High Renaissance art, featuring evocative, saturated colors and sophisticated painterly spaces. Some of these works, such as *Venus of Urbino* (1538), also incorporate complicated symbolism and erotic imagery. Such paintings would earn Titian an international clientele, but it was his later style, with its loose, expressive brushwork and introspective character, that would have the greatest influence on artists who followed him, particularly Rembrandt.

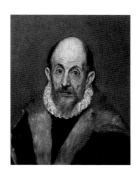

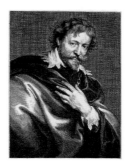

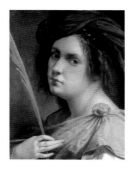

EL GRECO
(1541–1614)

El Greco was born Doménikos Theotokópoulos on the Greek island of Crete, then a territory of Venice. He first learned to paint in the stylized, medieval Greek Byzantine manner. Around 1567, El Greco moved to Venice, where he may have studied with Renaissance master Titian. "The Greek" soon developed a naturalistic style that incorporated Titian's vivid, expressive colors and penetrating facial expressions. It also included features of a new art called Mannerism, with its elongated limbs, swirling drapery, and dramatic gestures. El Greco's mystical, expressive art would be prized by many of his Catholic patrons, especially after he moved his workshop to Toledo, Spain, in 1577. He would exert a profound influence on later Spanish painters, including Diego Velázquez.

PETER PAUL RUBENS
(1577–1640)

Peter Paul Rubens was born in Siegen, in what is now western Germany, to Flemish parents. He was raised in Antwerp and studied art there under several Flemish Mannerist painters. During the early 1600s, Rubens spent years in Italy and Spain, where he absorbed and copied the works of antique Hellenistic sculptors, Renaissance masters, and the gritty Baroque paintings of Caravaggio. By 1610, Rubens had developed his own mature style, with its dynamic, fleshy figures set in verdant landscapes. This style became the embodiment of Baroque art, earning him royal commissions in both Catholic and Protestant Europe. Rubens also taught and influenced other high-profile artists, notably the Flemish-born portraitist Anthony van Dyck.

ARTEMISIA GENTILESCHI
(1593–ca. 1656)

Artemisia Gentileschi was born in Rome, the daughter of the painter Orazio Gentileschi, who inspired and fostered Artemisia's artistic talent. Her style, like Orazio's, was influenced by the dramatic lighting of Baroque master Caravaggio, but Artemisia's work became more emotionally intense than her father's, and she explored far more daring themes and compositions. Her early religious imagery features female protagonists, such as Judith and Susannah, and it depicts sexual violence with remarkable frankness. Gentileschi was herself the victim of a rape that her family successfully prosecuted. Despite the often explicit nature of her work, she was able to establish workshops in Naples and Florence, where she became the first female member of the Academy of Art and Drawing. She even traveled to England, where her work gained the attention of art-loving King Charles I.

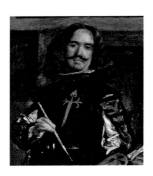

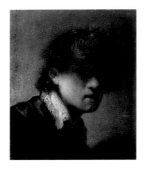

DIEGO VELÁZQUEZ
(1599–1660)

Diego Velázquez was born in Seville. As a young painter, he developed an earth-colored style that featured dramatic lighting and scenes of peasant life. In 1623, Velázquez was commissioned to paint a full-length portrait of King Philip IV in Madrid. The success of this work earned him the position of new court painter, and he moved permanently to the Spanish capital in 1624. Over the next twenty-five years, Velázquez's technique would evolve greatly. His finely detailed brushwork would give way to a more vibrant, exposed application of paint. He also developed more sophisticated color schemes and compositions, and he became a master of revealing subtle character traits in his sitters. These qualities were especially prominent in his images of ordinary and even disadvantaged members of Spanish society.

JAN VERMEER
(1632–1675)

Jan Vermeer spent most of his life in Delft, where he was born. His father, Reijnier Janszoon, was an innkeeper who also dabbled in the growing Dutch art market. Vermeer studied painting locally, and by 1653 had joined the local professional painter's guild, or Guild of Saint Luke. That same year, he married Catharina Bolenes, a well-to-do Catholic woman—a marriage for which he converted to Catholicism. The couple eventually moved into Catharina's family house, where Vermeer set up a studio. His paintings, which focused on domestic scenes, were distinguished by their vivid naturalism and shimmering colors. Yet Vermeer's business was never particularly successful, and Holland's economic downturn after the outbreak in 1672 of the Dutch war further weakened his trade and may have led to his untimely death.

REMBRANDT VAN RIJN
(1606–1669)

Rembrandt van Rijn was born in the Dutch city of Leiden, where he first studied art. By 1631, he had set up his own workshop in Amsterdam, and he quickly became a leading portraitist—serving the Dutch capital's thriving merchant class. Rembrandt's style changed over the course of his career. His early works are highly detailed and show a mastery of depicting materials and subtle expressions. Later works employ a radically simplified technique, with thick, exposed brushwork, dramatic use of light and shade, and striking emotional content. Rembrandt also accepted large-scale commissions, most famously the dramatic group portrait known as *The Night Watch*. But as his career progressed, dwindling commissions and a penchant for living beyond his means sapped his resources. He died penniless in 1669.

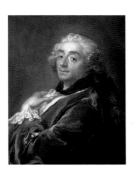

FRANÇOIS BOUCHER
(1703–1770)

François Boucher was born into a family of artists and craftsmen in Paris. He studied there with the Rococo painter François Lemoyne, and won a prestigious scholarship to study art in Italy. By 1734, he had become a faculty member at Paris's art school, the Académie. Boucher developed a brilliant, decorative style of painting, with brightly colored, witty compositions, richly depicted fabrics, and supple human flesh. This highly fashionable art greatly appealed to eighteenth-century French elites, and Boucher would receive the patronage of King Louis XV—first as head of the royal tapestry factory and then, in 1765, as primary court painter to the king.

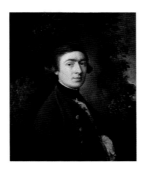

THOMAS GAINSBOROUGH
(1727–1788)

Thomas Gainsborough was born in Sudbury, England. After showing an early talent for drawing, he was sent to London in 1740 to study art. Gainsborough developed a style incorporating the delicate pastoral backgrounds of French painter Jean-Antoine Watteau and the incisive character studies of British artist William Hogarth and Flemish-born painter Anthony van Dyck. After moving to Bath in 1759, Thomas became a sought-after portraitist among the spa town's wealthy visitors. His paintings feature rough, "scratch"-like brushwork and often arresting facial expressions. The artist's growing fame enabled him to move his studio permanently to London in 1774, where his work was often exhibited at the Royal Academy. Gainsborough died of cancer in 1788.

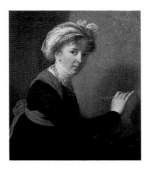

ÉLISABETH VIGÉE-LE BRUN
(1755–1842)

Élisabeth Vigée-Le Brun was born in Paris. The daughter of a successful portrait painter, she learned her craft from her father before his death in 1767. The young Élisabeth's graceful Rococo style quickly attracted clientele from the French aristocracy, and she became a member of the city's professional society of artists, the Académie, in 1783. She also became a favorite of French Queen Marie Antoinette, painting several of her portraits at Versailles. This connection with the royal family forced Vigée-Le Brun to flee Paris after the outbreak of the French Revolution but she eventually returned to France. Her fame spread throughout Europe in the early 1800s, and she traveled to Switzerland, England, and Italy to capture images of the elite, cementing her position as the era's leading female painter.

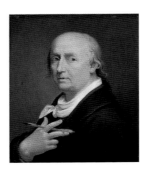

JOHANN HEINRICH WILHELM TISCHBEIN
(1751–1829)

Johann Heinrich Wilhelm Tischbein was born in Heine, in what is now the Hesse region of Germany. He came from a family of successful painters, and he developed a fashionable neoclassical style of art. Tischbein spent nearly two decades working in Rome and Naples, creating idyllic landscapes and mythological scenes. Today, however, he is best known for his relationship with the great German writer Johann Wolfgang von Goethe. Tischbein accompanied Goethe on his journey to Italy in the 1780s, and became a significant character in Goethe's travel book, *Italian Journey*. On that trip, the artist produced his most famous work: a full-length portrait of Goethe set against the antique ruins of the Roman Campagna.

SIR HENRY RAEBURN
(1756–1823)

Henry Raeburn was born in the village of Stockbridge, which is now part of Edinburgh. He began his career as a successful miniaturist. Soon he was producing full-size portraits in oil, a skill that was honed after studying Renaissance and Baroque masterworks in Italy. By 1787, Raeburn had established a profitable studio in Edinburgh. He became the leading painter of Scotland's Enlightenment era, portraying such cultural lights as author Walter Scott and architect Robert Adam. These images displayed the artist's sensitive brushwork and clear, unromanticized depictions of character. He was among the few painters of his day to be knighted, an honor bestowed a year before his death by King George IV—during the king's highly publicized royal visit to Scotland.

GILBERT STUART
(1755–1828)

Gilbert Stuart was born in the colonial village of Saunderstown, Rhode Island. He began studying art in the colony's capital, Newport, in 1770. The beginning of the American Revolutionary War forced Stuart to settle in England in 1775, where he studied with the leading British artist Benjamin West. Stuart had become a successful portrait painter by 1895, when he moved back to America—now the independent United States—and headed a studio in Germantown, Pennsylvania. Stuart captured the images of many famous early American leaders, including President John Adams and Supreme Court Chief Justice John Jay. But his most famous works were his portraits of George Washington, especially the full-length *Lansdowne Portrait*.

FRANCISCO DE GOYA
(1746–1828)

Francisco de Goya was born in Fuendetodos, a small town in the rural Spanish region of Aragon. A passionate, ambitious man, Goya moved to Madrid as a teenager and studied briefly with German-born master Anton Raphael Mengs. Beginning in 1775, he made a series of cartoons (painted preparatory designs) for tapestries commissioned by King Charles III. The success of these designs earned Goya a portrait commission from the king, and he later became court painter to Charles's successor, Charles IV. Goya's daring royal images use energetic brushwork and glittering colors, and they also suggest the personality flaws of his sitters. In addition, Goya became famous for paintings and prints that capture the horrors of war, works that helped redefine art as a method of exposing societal ills.

GUSTAVE COURBET
(1819–1877)

Gustave Courbet was born in the village of Ornans, in eastern France. He moved to Paris in 1839 to begin his art training. After experimenting with older painting styles, including Romanticism, Courbet developed a highly naturalistic art that depicted the rough, unsentimental life of rural France. At the Paris Salon exhibition of 1850–51 he exhibited his most famous early work, *Burial at Ornans*, which featured unflinching depictions of ordinary French people and the stark landscape of his homeland. Courbet soon became identified as a Realist painter, creating work that questioned the social inequalities—and even the sexual mores—of nineteenth-century France. Courbet's independent approach to art-making had a profound influence on Édouard Manet and later generations of French painters.

ÉDOUARD MANET
(1832–1883)

Édouard Manet was born in Paris to a family of wealthy diplomats. His art studies involved training under the progressive teacher and history painter Thomas Couture, as well as travels throughout Europe to absorb the work of Old Masters. Manet opened up his professional studio in 1856, and by the 1860s was producing art that combined Realism—the non-idealized depiction of modern life—with allusions to the great works of Renaissance and Baroque art. Some of these paintings, such as *Le Déjeuner sur l'herbe* (Luncheon on the Grass) of 1863, scandalized Paris with their provocative use of female nudity. Manet's art helped promote such exhibitions as the Salon des Refusés, which were the first to promote avant-garde artists. Manet also inspired the work of many Impressionist painters.

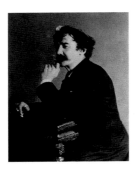

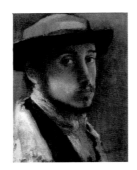

JAMES MCNEILL WHISTLER
(1834–1903)

James McNeill Whistler was born in Lowell, Massachusetts. He studied art in St. Petersburg, Russia, where his family lived for a time, and in the United States. Beginning in 1855, he would establish a professional career based in Paris and London. Whistler quickly absorbed the unsentimental style of French Realism, the fanciful, evocative imagery of the British Pre-Raphaelites, and the delicate compositions of Japanese prints. His first masterpiece, the ethereal *Symphony in White, No. 1: The White Girl* (1862), was shown at Paris's pioneering avant-garde exhibition, the Salon des Refusés, in 1863. Whistler later became a prominent member of the Aesthetic Movement, which promoted personal expression in all the arts. His wide social circle included Oscar Wilde and the American art patron Charles Lang Freer.

EDGAR DEGAS
(1834–1917)

Edgar Degas was born Hilaire-Germain-Edgar De Gas in Paris. He studied art at Paris's École des Beaux-Arts and in Italy. Degas became a brilliant draftsman, influenced by the graceful, fluid lines of neoclassical painter Jean Auguste Dominique Ingres. His mature paintings became famous for their surprising compositions, which reflected his interest in Japanese prints, and they featured unusual angles, sketchy, unfinished brushwork, and evocative colors. All of these elements gave the works a spontaneity that resembled Impressionist art, and Degas helped organize several early Impressionist exhibitions in the 1870s and 1880s. Yet he always resisted the Impressionist label for himself. Degas also produced brilliant sculptures that captured the subtle movements of young ballet dancers—a typical theme in all of his art.

JOHN SINGER SARGENT
(1856–1925)

John Singer Sargent was born in Florence, Italy, to wealthy American expatriates. He studied at the École des Beaux-Arts in Paris in the 1870s, where he was a highly admired student. Sargent developed a gift for portraiture, using expressive brushwork to capture materials and fleeting facial expressions. After moving his studio from Paris to London in 1886, he portrayed such celebrities as Teddy Roosevelt, John D. Rockefeller, Claude Monet, and Henry James. In 1907, Sargent closed his studio and began traveling the world. He captured his journeys throughout Europe, North America, and the Middle East in vivid, atmospheric watercolors. At the end of his life, Sargent used his fame to promote the study of art in the United States, founding a major gallery and school in New York City.

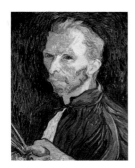

PAUL CÉZANNE
(1839–1906)

Paul Cézanne was born in Aix-en-Provence, in southern France. He moved to Paris in 1861, where he met Camille Pissarro and other artists who would become associated with the Impressionist movement. Cézanne himself presented works at several early Impressionist exhibitions in Paris, including the first show in 1874. But his independent nature—and his desire to develop a highly personal style—led him back to the solitude of Provence. He would spend the latter years of his career in his home and studio, near Aix. At the end of his life, Cézanne's increasingly abstract works were celebrated in Paris, especially by Pablo Picasso, Georges Braque, and the burgeoning modern art community.

VINCENT VAN GOGH
(1853–1890)

Vincent van Gogh was born in the village of Groot-Zundert, the Netherlands. He showed an early aptitude for drawing, and after a failed attempt to enter the ministry, he devoted himself entirely to art. Van Gogh spent the early to mid-1880s in the Hague and Antwerp, creating somber-toned paintings of Dutch peasant farm life. In 1886, he moved to Paris, where he experimented with such modern techniques as Pointillism—the use of tiny, solid-colored dots to create works that captured the subtleties of natural light. After moving to the southern French town of Arles in 1888, his style changed again. He incorporated thick brushstrokes and vibrant, saturated colors to capture both the Provencal region's atmosphere and his own emotional conflicts. Van Gogh committed suicide in 1890.

HENRI MATISSE
(1869–1954)

Henri Matisse was born in the northern French village of Le Cateau-Cambresis, near the border with Belgium. A former law student, he began studying art in 1891 at the Paris École des Beaux-Arts. Matisse's first major exhibition occurred at the 1905 Salon d'Automne, where his radically innovative paintings helped ignite the short-lived Fauvist movement. By the beginning of World War I in 1914, Matisse had developed an individual style that used expressive color combinations, elegantly abstract lines, and restless, flattened spaces. After the war, he moved his studio to southern France, near Nice, where he would experiment with art media outside of painting, including paper cut-out collages and stained-glass windows. All of these experiments, however, retained Matisse's mastery of line, form, and color.

GUSTAV KLIMT
(1862–1918)

Gustav Klimt was born in Baumgarten, on the outskirts of Vienna, the son of a gold engraver. After studying architectural painting at the Vienna School of Arts and Crafts, Klimt became a sought-after muralist. His paintings grace many of Vienna's public buildings, including the Kunsthistorisches Museum and the Burgtheater. By the 1890s, Klimt had developed his unique style of painting, which featured flattened forms, lavishly ornate decoration, and daring erotic content. Klimt was named first president of the Vienna Secession in 1897. This group helped spearhead Austrian modern art of all forms—painting, sculpture, and architecture. After 1905, Klimt would focus primarily on society portraits and elegantly stylized paintings of nature. He died in 1918, after suffering a stroke and contracting a lung infection during that year's flu epidemic.

GABRIELE MÜNTER
(1877–1962)

Gabriele Münter was born into a well-to-do family from Berlin. She studied for a time at the city's Women's Artist School before spending two years traveling throughout the United States between 1898 and 1900. Upon returning to Germany, she enrolled at the Phalanx art school in Munich, where she met her mentor and longtime partner, Wassily Kandinsky. From 1902 to 1914, she and Kandinsky lived and worked largely in Murnau, a village south of Munich. Together with other artists such as Marianne von Werefkin, Alexei Jawlensky, and Franz Marc, they founded several progressive art groups—the most famous of which was the *Blauer Reiter* (Blue Rider). This group would produce pioneering works of abstract and Expressionist painting. Münter's artistic output declined after her relationship with Kandinsky ended.

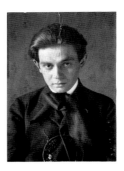

EGON SCHIELE
(1890–1918)

Egon Schiele was born in the town of Tulln, in eastern Austria. He moved to Vienna in 1906 to study art, and the following year met his mentor, Gustav Klimt. Like Klimt, Schiele developed a flattened, erotic visual style. But the younger artist's work was far more explicit and rough-edged. His paintings often warp human subjects into twisting, emaciated bodies. Yet Schiele's talent for line and expression give these works a riveting psychological quality. His most notable images are his portraits, which mostly depict himself, his lover, Walburga (Wally) Neuzil, and his wife, Edith, whom he married in 1915. Though his art was considered "shocking," Schiele did exhibit that work to some success during his lifetime. He died in 1918, a victim of the Spanish influenza epidemic.

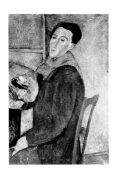

AMEDEO MODIGLIANI
(1884–1920)

Amedeo Modigliani was born in Livorno, Italy. His family had lost much of their fortune in an economic downturn before his birth, and Modigliani struggled financially his entire life. After studying art in Livorno and Florence, he moved to Paris in 1906. He lived the rest of his life there, moving from one cheap apartment to another in the Montparnasse district. Modigliani's mature style featured elongated, abstracted human figures, a style he would use in both his painting and his sculpture. He made a wide variety of acquaintances in the Parisian art community, from Pablo Picasso to Chaim Soutine, and his works were exhibited to moderate critical acclaim in Paris and London. After years of fragile health and alcoholism, Modigliani died of tubercular meningitis.

JOAN MIRÓ
(1893–1983)

Joan Miró was born in Barcelona, Spain, and grew up in the city's medieval Gothic quarter. The young Joan showed an early talent for drawing, beginning his art studies around 1900. After experimenting with Fauvism, Cubism, and other early modernist styles, he began producing images in which each individual object had symbolic meaning. He also began abstracting these objects into simplified, brightly colored, curving shapes. These shapes seemed to reflect the coastal Mediterranean landscape of his homeland. Miró's symbolic art often included portraiture. His earliest portraits have a fanciful realism suggestive of medieval folk art. In later portraits, the facial forms were reduced to basic shapes and cleverly rearranged on the canvas.

MAX BECKMANN
(1884–1950)

Max Beckmann was born in Leipzig, Germany. After completing his art studies at the Weimar Academy in 1902, he traveled to Paris—where he devoured the works of Édouard Manet and the French Impressionists. Beckmann's early style incorporated the Impressionists' use of color, the compositions of the Old Masters, and his own expressive brushwork. During World War I, Beckmann suffered a mental breakdown while serving as a medical orderly. After the war, he used this experience to develop a mature, highly introspective art. The rise of Nazism forced Beckmann to flee Germany in 1937. He spent his remaining years in Amsterdam and the United States.

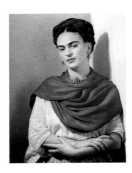

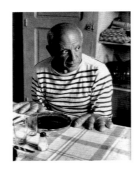

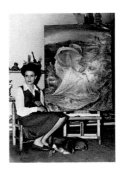

FRIDA KAHLO
(1907–1954)

Frida Kahlo was born in Coyoacán, Mexico, a community that was then just outside Mexico City. Her full name was Magdalena Carmen Frieda Kahlo y Calderón. After surviving polio and a serious bus crash during her youth, Frida began painting as a teenager. She developed a whimsical style of art that combined rich colors, Mexican folk art traditions, and highly symbolic elements. In 1929, Kahlo married Mexico's leading muralist, Diego Rivera, beginning a stormy relationship that would prove both beneficial and frustrating to her. Her art was first exhibited in Europe during the 1930s, and she became highly admired by André Breton and other Surrealists. Today, Frida Kahlo's self-portraits are among the most famous images of feminist art.

PABLO PICASSO
(1881–1973)

Pablo Picasso was born in Málaga, Spain. Together with Georges Braque, he helped spearhead twentieth-century modern art with his Cubist paintings and collages. The subsequent devastation of World War I would inspire Picasso to explore new styles, including "neoclassical" realism. When war again struck Europe in the late 1930s—this time in Picasso's homeland—his art developed a new synthesis. His figures have the "reconstructed" look of early Cubist paintings, but the shapes are now rounded and more organic. Moreover, works such as *Guernica* (1937) possess an extreme psychological intensity, reflective of the destruction caused by the Spanish Civil War. In his later years, Picasso became the world's most celebrated modern artist, producing important artworks into the 1970s.

LEONORA CARRINGTON
(1917–2011)

Leonora Carrington was born in the English village of Clayton Green, the daughter of a wealthy British industrialist. She was a rebellious spirit who insisted on studying art against her father's wishes. Carrington met the Surrealist painter Max Ernst in London in 1937. The two soon began a romantic relationship, prompting Ernst to divorce his wife. Carrington developed her own Surrealist style while living with Ernst in southern France, but World War II would end their idyllic life. Ernst was arrested by the French authorities, and Carrington escaped to Spain, where she suffered a nervous breakdown and was committed to an abusive psychiatric institution in Madrid. Carrington eventually fled Europe and settled in Mexico, where she spent most of her long life.

ANDY WARHOL
(1928–1987)

Andy Warhol was born in Pittsburgh, Pennsyl-
vania, and studied commercial art at the local
Carnegie Institute of Technology. He began his
professional career in New York City in 1949.
Warhol's early work in commercial advertising
led him to experiment with industrial image-
making techniques—such as silk-screen
printing—in his art. Warhol's fame took off in
1962 after his exhibition at New York's Stable
Gallery, which featured Pop Art images of
Campbell's soup cans, Coca-Cola bottles, and
Marilyn Monroe. Warhol fostered this fame by
founding his own studio, the Silver Factory,
where he further developed his style and
produced his groundbreaking avant-garde
films. The Factory promoted the work of many
different artists—from the rock band The
Velvet Underground to the pioneering graffiti
artist Jean-Michel Basquiat.

CHUCK CLOSE
(b. 1940)

Chuck Close was born in Monroe, Washing-
ton. A gifted draftsman and technician, he
overcame childhood dyslexia to study at the
Yale University School of Art and Architecture,
where he created masterful student works
using fluid, expressionist brushstrokes. But
after his graduation in 1965, Close created a
new art-making technique that came to be
known as photo-realism. His first photo-
realist portraits were exhibited in 1969. Close
suffered a seizure in 1988, which left him
partially paralyzed, yet he continued to
develop as an artist. By the early 2000s, he
was producing a new series of images called
"tapestries"—huge artworks that contained
thousands of patterns of colored thread.

LUCIAN FREUD
(1922–2011)

Lucian Freud was born in Berlin to a promi-
nent German-Jewish family. The Freuds fled
Germany in 1933, the year Adolf Hitler's Nazi
party came to power, and they settled in
England. After studying at several art schools
in London, including Goldsmiths college,
Freud became associated with a group of
London painters who were incorporating
figural imagery into modern art. Freud began
to specialize in portraits during the 1950s,
using friends and family members as his
earliest subjects. Toward the end of his life,
he made celebrated portraits of Kate Moss,
Queen Elizabeth II, and other prominent
British figures.

GERHARD RICHTER
(b. 1932)

Gerhard Richter was born in Dresden, Germany. After studying at Dresden's Academy of Fine Arts in the early 1950s, Richter spent many years working on murals for the East German government. He fled to West Germany in 1961, just before the construction of the Berlin Wall. During the 1960s, Richter began exploring a variety of styles—including the monochrome color field paintings popularized by Yves Klein. His most famous works combine photography, printmaking, and painting in original ways: using images made with one method as the basis for creating new images in another. Later on, he explored such techniques as dragging wet paint directly over photographs, or making watercolors by applying drops of ink to paper. Richter also designed a stained-glass window for Cologne Cathedral, which was installed in 2007.

FURTHER READING

Beyer, Andreas. *Portraits: A History.* New York: H.N. Abrams, 2003.

Calabrese, Omar. *Artists' Self-portraits.* New York: Abbeville Press, 2006.

Campbell, Lorne. *Renaissance Portraits: European Portrait-painting in the 14th, 15th and 16th Centuries.* New Haven: Yale University Press, 1990.

Close, Chuck. *The Portraits Speak: Chuck Close in Conversation with 27 of His Subjects.* New York: A.R.T. Press, 1997.

Freeman, Judi. *Picasso and the Weeping Women. The Years of Marie-Thérèse Walter & Dora Maar.* New York: Rizzoli, 1994.

Freud, Lucian. *Freud at Work.* New York: Alfred A. Knopf, 2006.

Gibson, Robin. *Painting the Century: 101 Portrait Masterpieces, 1900–2000.* London: National Portrait Gallery, 2000.

Klein, John. *Matisse Portraits.* New Haven: Yale University Press, 2001.

McLanathan, Richard B. K. *Gilbert Stuart.* New York: Abrams, 1986.

Ormond, Richard. *John Singer Sargent: Complete Paintings.* New Haven: Yale University Press, 1998.

White, Christopher and Quentin Buvelot (eds.). *Rembrandt by Himself.* London: National Gallery Publications, 1999.

PHOTO CREDITS
The illustrations in this publication have been kindly provided by the museums, institutions and archives mentioned in the captions, or taken from the publisher's archives, with the exception of the following: © Achim Bednorz: p. 16; © akg-images / Cameraphoto: p. 17; © akg-images / Erich Lessing: pp. 27, 49, 61, 124 center, 128 right; © akg-images / The National Gallery, London: p. 71; © Archives Matisse: p. 91; © Artothek: pp. 25, 35, 69, 99, 130 left; © Artothek / Alinari: p. 15; © Artothek / Blauel / Gnamm: pp. 37, 67; © Artothek / Imagno: p. 83; © Artothek / Paolo Tosi: p. 33; © Artothek / Joseph S. Martin: pp. 39, 53; © Artothek / Photobusiness: p. 45; © Artothek / U. Edelmann - Städel Museum: p. 73; © Art Ressource / Erich Lessing: p. 29; Associated Press / Richard Drew: p. 139 left; © Atelier Richter: Cover, p. 121; © bpk / The Trustees of the British Museum: p. 14; © Bridgeman Images: pp. 18, 23, 31, 57, 65, 77, 85, 105, 119, 132 center; © Bridgeman Images / Her Majesty Queen Elizabeth II, 2014: p. 59; © Chuck Close, courtesy Pace Gallery: 117, 139 center; © Collection Stefan T. Ellis: p. 115; © Corbis: p. 87; © Hélène Adant: p. 135 right; © Jorge Contreras: 109; © London Stereoscopic Company: p. 134 left; Nickolas Muray: p. 138 left; © SMK Photo: p. 95; Sterling and Francine Clark Institute, Williamstown, MA: p. 134 center; © The Hispanic Society of America, New York: p. 79; © The Metropolitan Museum of Art, New York: p. 55

Cover: Gerhard Richter, *Betty*, see pp. 120/21

Prestel Verlag, Munich
A member of Verlagsgruppe Random House GmbH

Prestel Verlag
Neumarkter Strasse 28
81673 Munich
Tel. +49 (0)89 4136-0
Fax +49 (0)89 4136-2335

Prestel Publishing Ltd.
14–17 Wells Street
London W1T 3PD
Tel. +44 (0)20 7323-5004
Fax + 44 (0)20 7323-0271

Prestel Publishing
900 Broadway, Suite 603
New York, NY 10003
Tel. +1 (212) 995-2720
Fax +1 (212) 995-2733

www.prestel.com

Library of Congress Control Number: 2014940420; British Library Cataloging-in-Publication Data: a catalog record for this book is available from the British Library; Deutsche Nationalbibliothek holds a record of this publication in the Deutsche Nationalbibliografie; detailed bibliographical data can be found under: http://www.dnb.de

Prestel books are available worldwide. Please contact your nearest bookseller or one of the above addresses for information concerning your local distributor.

Editorial direction: Claudia Stäuble
Project management: Dorothea Bethke
Copyedited by: Danko Szabó, Munich
Layout: Mogwitz Design, Munich
Production: Astrid Wedemeyer
Separations: Reproline Mediateam, Munich
Printing and binding: Druckerei Uhl, Radolfzell

Verlagsgruppe Random House FSC® N001967
The FSC®-certified paper *Hello Fat matt*
was supplied by Deutsche Papier.

ISBN 978-3-7913-4980-0